CANALETTO

The life and work of the artist illustrated with 80 colour plates

ANTONIO PAOLUCCI

THAMES AND HUDSON

Translated from the Italian by Diane Goldrei

Printed in Italy

Life and works

Antonio Canal was born in Venice in 1697. We are told by his biographers Mariette and Zanetti that he belonged to the aristocratic Da Canal family, but although Canaletto himself liked to give this impression, there would appear to be little truth in the claim. His father Bernardo made a comfortable living as a scene designer for the theatre. Far from being related to the Venetian nobility, the Canal family aspired to membership of the hard-working and thrifty Venetian middle class, immortalized in the plays of Goldoni, which was to play a leading role in the coming century.

Antonio, together with his brother Cristoforo, began his artistic career as a scene painter and grew up in the world of the Venetian theatre, among impresarios, actors and musicians. In the San Cassiano and Sant'Angelo theatres, he painted the back-drop for Vivaldi's *Incoronazione di Dario*, for Chelleri's *Penelope la casta*, for Pollarolo's *Farnace* and Orlandini's *Antigone*. It would be interesting to know what Canaletto's work was like in those years from 1716 to 1719, but the temporary nature of painting for the theatre has left us without any clues as to Canaletto's development in the early stages of his career. His work would very probably have been influenced by the exaggerated architectural perspectives of the Bibbiena family, virtuoso stage-designers from Bologna. He must also have been familiar with the dramatic landscape with ruins of Marco Ricci, who returned to Venice from London in 1716.

Canaletto cannot have been entirely in sympathy with the requirements of eighteenth-century melodrama, the far-fetched plots and the conventions of operatic theatre. As an eighteenth-century painter, he belongs to the bourgeois, rational tradition with Pietro Longhi and Carlo Goldoni, rather than the emotional literary tradition with Metastasio and Tiepolo. This may explain his impatience, dissatisfaction and finally his break with the theatre, to which Zanetti refers (1771): 'Having left the theatre, exasperated by

the capriciousness of the playwrights, he went as a young man to Rome and dedicated himself to painting *vedute* [views] from nature. This was around 1719, when, as he himself said, he solemnly repudiated the theatre.'

Canaletto's renunciation of the theatre and his break with the world of librettists and impresarios cannot have been quite as sudden as Zanetti would have us believe, for at the beginning of 1720 he was working in Rome with his father on the scenery for two operas by Scarlatti. But there is no doubt that Canaletto's visit to Rome marked a decisive turning-point in his stylistic development, and that however gradual and cautious the changes that followed, they certainly stem from this period. It was in Rome that Antonio Canal began to paint the naturalistic *veduta* – a view of a recognizable place – for the simple reason that the modern landscape, the 'view from nature' which Zanetti mentions, had originated in Rome nearly a century before in the new freer intellectual and moral climate, which preceded the artistic revolution ushered in by Caravaggio. The old hierarchy of the genres was giving way under the pressure of new and exciting ideas and theories about painting. Michelangelo da Caravaggio was speaking for the new era when he said: 'As much skill goes into a good flower painting as into a figure painting.' During the first half of the seventeenth century many young artists, particularly from the north, had scoured Rome and the surrounding countryside for places whose visual possibilities had not yet been explored, whose evocative beauty was rooted in reality. Architectural cross-sections of the Colosseum or the Pantheon, or painstaking reliefs of famous ruins, were now less fashionable than scenes of roofless Roman baths overgrown with shrubs, or goats, with their herdsmen, grazing among crumbling pillars, or hovels clustered around triumphal arches, and imperial forums overrun with flocks and beggars. The vision of the artist expanded to take in an ever wider portion of reality, with its wealth of detail and its contrasts. For those artists, the Roman landscape, of desolation and grandeur, of sublime beauty and abject poverty, built up on huge historical strata, assumed that ideal and poetic image which it still holds for us today.

4

It was thus from this most august and inspiring of settings that a new and fresh approach to landscape painting emerged. Clearly the most outstanding of these artists was Viviano Codazzi, who has been rightly described by Briganti as ' the inventor of the realistic view '. With Codazzi the view ceases to be a rather limited genre. The seriousness of his approach takes the view beyond the realm of the merely picturesque, and places it on more solid ground. Codazzi avoids the facile landscape with raised horizon, or the unadventurous painting of a well-known place or monument. The view becomes a true and objective rendering of reality, and of the feeling of reality, with perspective and light and shade treated as they appear to the eye.

Codazzi's finest works (*Palazzo Gravina, Piazza del Mercato with the Revolt of Masaniello, Torre di San Vincenzo* in the Longhi collection) date from the long years, 1633 to 1647, that he spent in Naples. These are the works which represent the height of Codazzi's achievement and pave the way towards the great Venetian view painters of the eighteenth century, Canaletto and Bernardo Bellotto. In Codazzi's mature painting of the façade of the Palazzo Gravina, passers-by creep around the corner, and the carriage rolls lazily down the slope; and his Naples is gloomy and forbidding. We find the same aura of neglect in Canaletto's yellow and pink tinted dwellings along the Rio dei Mendicanti, where beggars and loafers shuffle past the walls of anonymous houses to enjoy the sunshine. The galley being mended in the boathouse at the Torre di San Vincenzo, in Codazzi's painting, with its slackened rigging and huge oilcloth awning covering the deck, the workers bustling around the forecastle, is an eye-witness account of human industry. Such scenes at the Arsenal, the Giudecca and the Punta della Dogana are later to be found time and again in the work of Canaletto. With his dispassionate yet sensitive poetic insight, Codazzi captures the exact quality of the heavy Levantine light in Naples. More than a century later, this same poetic insight enabled Bellotto to give a truer rendering perhaps than any other artist before or since of the intense and transparent cold of the northern Italian landscape.

I have stressed the influence of Viviano Codazzi because the history of the Venetian view painters, particularly Canaletto, abounds in misconceptions. Much importance has, for example, been attached to Joseph Heinz, a mediocre seventeenth-century German painter, a naturalized Venetian citizen, some of whose uninspired carnival scenes in Campo San Polo and Piazza San Marco were virtually given pride of place among the precursors of the Venetian view painters in the recent exhibition in Venice in 1967. In fact, his approach to Venice is singularly unimaginative. He reduces the famous buildings to highly-coloured, gaudy back-drops for a puppet show, and he is remarkable only as an indication of the depths to which Venetian art had sunk in the seventeenth century. We certainly cannot hope to find Canaletto's cultural roots in the mediocre and degenerate art of seventeenth-century Venice. It is no accident that Zanetti links Canaletto's repudiation of the theatre with his departure for Rome, although, with the traditional reluctance of Venetian art historians to acknowledge debts to the rest of Italy, he gives the impression that Canaletto's interest in view painting owed more to the archaeological Roman landscape than to the great landscape painters of the seventeenth century.

It is of course true that artists, especially young artists, cannot fail to study and learn from the work of their contemporaries, and Canaletto was no exception. Much more is known today about Canaletto's early years from such leading scholars of Venetian painting as Morassi, Constable and Pallucchini. They have singled out those artists, among Canaletto's contemporaries in Rome and Venice, who made the strongest impression on the young stage designer, and who influenced his early stylistic development. They included Gian Paolo Pannini, whose work was probably known in Rome, and who specialized in painting ruin scenes (a recurrent theme in seventeenth-century art), Marco Ricci, who was in Venice from 1716, and above all the Dutch painter Van Wittel. Canaletto could have come across his work in Venice, as he had visited the city in 1695, or he may even have come into direct contact with him in Rome. The connection between Canaletto and Van Wittel, long

neglected by historians (although as early as the second half of the eighteenth century Mariette had remarked that Canaletto painted '*dans la manière de Van Wittel*'), is central to the history of the Venetian view in the eighteenth century.

Although Van Wittel was a lesser artist than Canaletto or Bellotto, and a less acute observer of reality, the history of the eighteenth-century Venetian view virtually orginates with him. He is the forerunner of the painters of the age of rationalism and Enlightenment, who rejected the baroque and proclaimed the new bourgeois, lay society. Van Wittel had been painting views for many years, certainly since 1681, when he visited Venice in 1695. He had a decisive influence on the development of Luca Carlevaris (between 1685 and 1690, when Carlevaris was in Rome he still followed the conventions of the *veduta ideata* – imaginary view – but by 1703, with his famous series of Venetian views he had established himself as a topographical view painter). Van Wittel greatly influenced the later development of Canaletto's style, both directly in Rome, and indirectly in Venice through the work of Carlevaris. There is little trace of Van Wittel's clear-cut style, his pearly tones, his limpid, golden horizons, or his cool and rational approach, in Canaletto's early works. In the first stages of his artistic career, Canaletto's colours tended to be dark and contrasting, reflecting a certain baroque restlessness and a determined striving after realism. Later, after a development which affected the entire course of Venetian painting, Canaletto's palette lightened. It was then that Canaletto applied the teachings of Van Wittel, bringing his own poetic quality to the Dutch master's honest, straightforward approach.

It was in Rome, therefore, that Canaletto, surveying the recent history of Italian painting, had come across the northern view painters and gone on to discover Viviano Codazzi and Van Wittel. His renunciation of the theatre, of theatre design and imaginary views, was, however, a gradual process. Antonio Canal was cautions by nature, and as little inclined to risk his talents as his money. For several years, until he finally devoted himself to view painting, he conti-

nued to design for the theatre. At the same time, he was gradually discarding traditional methods of painting and exploring new possibilities. A series of paintings recently identified by Morassi and Pallucchini, and dating approximately from between 1720 and 1723, show us how he wavered between theatre design, the imaginary view, and his ever-increasing concern with realism. The two caprices in the Cini collection, for example, although heavily influenced by Marco Ricci's emotional romanticism, are still conceived on the lines of stage back-drops. Although the fall of a shadow on a crumbling pillar, or the effect of light on decaying plaster, indicate an exceptional grasp of reality, these pictures could still undeniably serve as backgrounds for the heroines of Scarlatti or Vivaldi operas. In some early archaeological views, in private collections, (which may be the paintings of antique subjects mentioned by Zanetti) Canaletto's main concern is still with dramatic effect, but there is also an attempt at realism and objectivity which seems closer to Codazzi and Tassi than to Marco Ricci.

Although his early works betray an uncertainty of style, in 1722 and 1723 Canaletto still appears to be leaning towards ruin-pieces in the manner of Marco Ricci. There are the two allegorical tombs of 1722, part of the series commissioned by Owen McSwiney from such artists as Pittoni, Cimaroli, Piazzetta etc., which was to decorate the home of the Duke of Richmond. In 1723 there is the *Capriccio* (*pls 1-4*), dated and signed ' IO ANTONIO CANAL ', now in a private collection in Milan. It was recently brought to light by Morassi and is now regarded as the most important landmark in the course of Canaletto's early career. The 1723 painting is of outstanding interest because it seems to record, just when Canaletto is on the verge of solving his stylistic dilemma, the contradictory strands in his cultural formation and the tentative, gradual process of his early development. The influence of scene painting is still apparent in his use of perspective, based on the juxtaposition of the ' wings ' in the foreground, and the gradation of the colours, which lighten towards the background. There are echoes of the journey to Rome, not so much in the haphazard arrangement of classical monuments, typical of the

caprice, as in fragments of close observation of nature – passages of great realism – which stand out rather like pieces in a collage. (Note in particular, the road leading to Constantine's arch, and ruined wall with a slender poplar outlined against the gilded haze of a Roman sunset, *pl. 4.*) On the right-hand side of the picture, Canaletto has painted his first lagoon landscape, clear and almost pearl-like as in some of Van Wittel's backgrounds, where a strange Levantine Venice surfaces in the distance through the mist, beyond a solitary boat at anchor in the harbour.

Canaletto's long search for stylistic certainty culminates in the four paintings, formerly in Liechtenstein, also dating from around 1723, which may justly be claimed as his first masterpieces. There is still a tendency, as Pallucchini notes, to exaggerate and distort dimensions – an obvious inheritance of his training as a scene painter which he was to have difficulty in losing completely. Thus the sides of Piazza San Marco seem too wide and they appear to taper off towards the back too suddenly, as if to place deliberate emphasis on the theatrical qualities of the setting. *The Grand Canal: looking north-east from the Palazzo Balbi to the Rialto Bridge (pls 5-7)* in the Crespi collection betrays the same search for effect: the canal plunges through architectural wings and carefully contrasting blocks of shadow to give the picture perspective depth. Nevertheless, in spite of the artificial perspective and the echoes of theatre design, these works are a major step forward. They represent not so much an improvement in quality, as a consolidation of his style and a reappraisal of his approach. It is in these works, when Canaletto the view painter finally sheds his baroque leanings, that we see the full import of the lessons learned in Rome from the realism of the great seventeenth-century landscape paintings.

It is hard for us today to appreciate the magnitude of Canaletto's achievement with these views. Until then, no painter, Venetian or foreign, had ever suceeded in capturing Venice on canvas as it really was: the greenish-yellow colour, the still waters of the lagoon in high summer, the fall of the sunlight on the crumbling plaster, on the dark stones of the princely palaces, whose marble pinnacles

stand out against the sultry sky, the patches of shade at the corners of the canals, where gondolas cluster and boats sway at their moorings, and at the foot of the buildings, the teeming life of sailors, idlers, beggars, fishermen, gentlemen and servants. Here for the first time was an artist with a true understanding and appreciation of the city as we still know it today: at once imposing, unassuming, spectacular and humdrum, balanced between water and sunlight, with its salty air and vast restless clouds.

Canaletto surpasses even Carlevaris, the first Venetian view painter. Carlevaris certainly had an important influence in these years on Canaletto's choice of subject, on his technique and perhaps also on his style. The rather painstaking concern with detail, the over-liberal use of *chiaroscuro* contrast, and the handling of the figures, in Canaletto's first works bear witness to the influence of his predecessors, and perhaps even to the personal teaching of Carlevaris. Carlevaris' own works, although realistic views, peopled with life-like figures, do not match the faithfulness to nature which the young Canaletto was striving to achieve. Nor could Carlevaris, painter of receptions for foreign ambassadors at the pier of San Marco, have succeeded in capturing the flavour of a plebeian quarter of the city, unfrequented by tourists, as did Canaletto in his *Rio dei Mendicanti* in the Crespi collection (*pls 8-9*).

The idea of painting one of the poorest, most out-of-the-way parts of the city may have come to Canaletto from Roman painters. He may have had in mind a Venetian equivalent of the Roman *bambocciata* – paintings of beggars or peasants mainly by Dutch- and Flemish-born artists. The original intention, however, is transcended by the work itself, whose sincerity and sure grasp of reality call to mind nineteenth-century naturalism. These squalid pink buildings, overcrowded and crumbling, where the damp creeps up the peeling walls, the delapidated hovels, the warehouses and boatyards cannot be described as picturesque. They have the objectivity of a sociological report, as if Canaletto had wanted to show that you had only to look just beyond the classical Venice of the guide-books to find the other face of Venice, poor and unhealthy, inhabited by

porters, gondoliers and shipyard workers. But it is hardly likely that the foreign customers for whom these views were largely intended would have appreciated these novel glimpses of the city. Tourists and visitors to Venice who bought pictures as a souvenir wanted to be reminded of the famous or at least typical parts of the city. Thus Canaletto, who as a middle-class professional man tended to respect the wishes of his clients, came to concentrate on the Venice familiar to the tourist and systematically chose as his subjects the famous landmarks and beauty spots in the city. This concession to the requirements of the market did not, however, entail any lowering of the high standards that he set himself, or slacken his slow but steady artistic development.

The four views painted for Stefano Conti, a collector from Lucca, as well as the *SS. Giovanni e Paolo and the Scuola di S. Marco* (*pls 10-11*) in Dresden, a very fine version of one of the Conti paintings, and the *Entrance to the Grand Canal: looking east* (*pls 12-13*), also in the Gemäldegalerie in Dresden, all belong to this period around 1725. There are still traces of the scene designer's approach in the complex composition, based on diagonals, of the *Entrance to the Grand Canal*, and in the contrast between the shadow striking the monumental buildings and the dazzling houses, bathed in sunlight on the left-hand side of the view of *SS. Giovanni e Paolo*. Nevertheless, these works mark a further step foward in Canaletto's stylistic development. The impetuous naturalism of his earlier works has given way to a more even, purer style. His admirable rendering of the houses alongside the canal in *SS. Giovanni e Paolo* (*pl. 11*) is a masterpiece of observation, which calls to mind Vermeer. He captures this moment of life along the sunlit canal, noting the exact play of light and shade on every detail, with the impartiality and feeling for reality of a true poet. The porter on the quay, picked out by the sun, is as much a part of the scene as the nobleman in an orange cloak who has stopped to talk just in front of him. The light dances on the roofs of noble mansions as it does on the tiny house with the high-water marks on its walls, worn away by the salty air. The houses of rich and poor

alike bask in the sunlight on this summer day, which throws into relief the sunbaked pink walls, the damp patches and the shady corners. Perhaps only Carpaccio, so long ago, had gazed upon his city with such fondness and such objectivity. But the Venice of Carpaccio's day was still a city of miracles and spectacle, a stage for historical events; Canaletto's Venice was a modern city with a life of its own and its own customs and values: a world in itself which could be examined and analysed, enjoyed for its beauty and variety. Antonio Canal was not just an aesthete interpreting an incomparably beautiful city; he was one of the great poets of modern life.

Canaletto's reputation as an artist was growing throughout Europe, and art dealers and great collectors from Zanetti to McSwiney, from the French ambassador to the Duke of Richmond and Marshal Mathias Schulenberg, were competing for his friendship and his pictures. In this period, Canaletto produced such masterpieces as the *Campo S. Giacometto (pls 14-15)* in Dresden, the *Bacino di S. Marco, looking north (pls 16-17)* in Cardiff, the *Dolo on the Brenta (pls 18-21)* in the Ashmolean Museum, and the great *Grand Canal: The Stonemason's Yard; Sta Maria della Carità from across the Grand Canal (pls 22-5)* in the National Gallery in London.

Canaletto's search for objective truth reaches its highest point in *The Dolo on the Brenta* and *The Stonemason's Yard.* In these works Canaletto brings the Dutch painter's close observation of detail, of the texture of things in the sunlight, to the Italian confidence in measurable space. How beautifully Canaletto has captured the brown and pink tiles of the mills of Dolo, the yellows, the ochres, the faded grey of this Venetian village bathed by the midday sun, the trembling leaves of the poplars on the banks of the Brenta, the women pausing to gossip on the doorstep, while a group of gentlemen in travelling clothes wait to step on board. No less memorable is that corner of Venice opposite the Carità, where the stonemasons are busily at work. With the dispassionate visual precision of a Dutch painter, Canaletto paints the wooden shed in the foreground, the yard in the shade cluttered with half-finished goods, blocks of stone

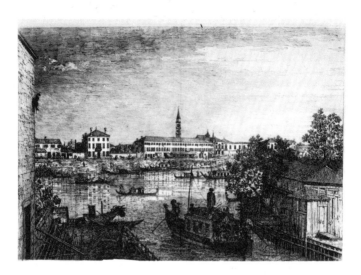

Entering the village of Dolo (etching for the 1744 volume).

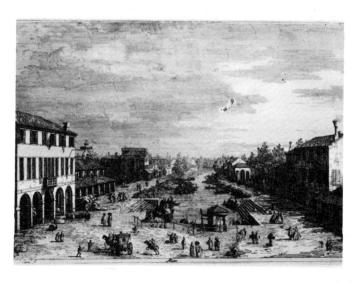

View of Mestre (etching for the 1744 volume).

and rubble, the dark church, and on it the darker shadow of the building facing it on the other bank of the canal. He shows us how the marble chiselled by the masons shines in the sun like the marble church spires, how the wooden planks of the shed look different from each other in the strong light, how the colours in a shadow range from lustrous black and transparent violet to brown, ochre and pinkish tones. This painting has very close affinities with Bellotto's great European views in Gazzada, Pirna and Warsaw, although Bellotto's works are slightly less vibrant, rather cooler in tone and a little more detached.

In these works, therefore, Canaletto had achieved a remarkable visual clarity; but Canaletto's stylistic development was not as yet complete. In the years from 1727 to 1730, when he was in his early thirties, and his paintings were fetching high prices all over Europe, his style underwent a decisive change. This was the moment of the discovery of 'painting in light', the moment which has been imprecisely but vividly called 'the conquest of light'. Canaletto had of course long since mastered the use of light, but his lighting was still essentially that of the seventeenth century. In his earlier work, he records transient shadows and contrasts; his light is thick, almost tangible, but while it gives substance, its effect is also at times dramatic. Now, however, Canaletto's palette lightens considerably: the velvety shadows become precise, the colours are graded and contrasted in ever lighter tones, the colouring of the sky and the lagoon waters becomes even, crystalline and radiantly luminous. Canaletto now shows us a new Venice, clean and clear, as if washed by spring rain and swept by a gentle breeze. No storms threaten these clear blue skies, and the green water of the lagoon is grazed occasionally by an oar or the prow of a gondola like a diamond on glass. There is no longer a far-away mist over the canals; one can clearly make out even the most distant details. This important and far-reaching change in Canaletto's style in these years can be followed if we compare the *Grand Canal: looking north-east from the Palazzo Balbi to the Rialto Bridge* (pls 26-8) in the Uffizi, painted around 1726, the *Grand Canal: the Rialto*

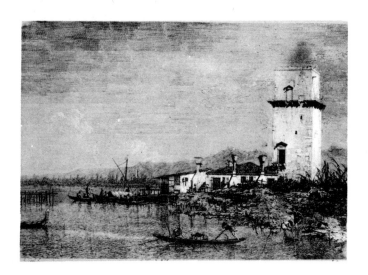

Torre di Marghera (etching for the 1744 volume).

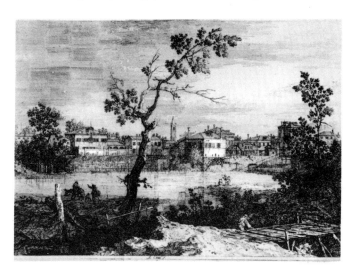

River scene (etching for the 1744 volume).

Bridge from the north, and the magnificent large canvases of the *Reception of the Imperial Ambassador, Count Giuseppe di Bologna, at the Doge's Palace* and *The Bucintoro returning to the Molo on Ascension Day (pls 29-35),* dating from around 1730, in the Crespi collection.

This change in Canaletto's style was neither a fortuitous nor an isolated phenomenon. Although like all great artists Canaletto was following his own personal line of development, this change reflects a general trend in the history of Venetian art from the 1720s to the 1730s. The concern with *chiaroscuro* and dramatic effects was giving way to an interest in colour seen in natural sunlight in all its purity, in what was to be the last and gayest phase in Venetian art history. Around 1725 Marco Ricci had led the way with pale colours, painted on kid, which were extraordinarily clear, luminous and accurate. His view of a villa belonging to the Venetian Academy, and the *Courtyard with figures* at Windsor Castle, for example, had a decisive influence on Canaletto's development. Tiepolo also reflects this tendency. With the frescoes painted between 1729 and 1731 for the Archbishop's Palace (Palazzo Dolfin) at Udine, and the Milanese frescoes, he abandons the baroque restlessness of his earlier works for dramatic, radiantly coloured paintings in the manner of Veronese. Piazzetta too, in his *Assumption* in the Louvre, lightens his palette and bathes the idyllic compositions of his later years in sunlight. Canaletto was thus part of a general development in Venetian painting, and was perhaps its greatest, most coherent exponent. It is at this point that Van Wittel's influence comes to the fore, although Canaletto, with the serenity and 'happy genius' rightly ascribed to him by Zanetti, transforms the Dutch master's sober, restrained realism into true visual poetry.

The series of views which formerly belonged to the Princes of Liechtenstein, now dispersed among various public and private collections – *The Dogana and the Giudecca Canal (pl. 36), The Quay of the Dogana, (pls 37-9),* etc. – show how Canaletto's visual field now expands. In his new, flowing, limpid style, he paints increasingly large scenes in which the sky and water of the lagoon play an ever

more important role. He now turns from painting self-contained corners of the city to vast panoramas (the Riva degli Schiavoni, the Bacino di San Marco, the area around the Dogana) which are large enough to encompass the bustling life of the city. We can see how lightening his palette and giving up detailed description of the play of light and shade allow him to bring about such a change. It was now the overall effect of light which concerned him and its ability to give unity and harmony to a composition.

Brandi has rightly said that ' Canal's *plein air* [open air] is not really *plein air* at all. The jewel-like clarity of the images excludes rather than suggests the touch of air.' This has to be emphasized in order to grasp the originality and greatness of the mature Canaletto, and to avoid misinterpreting him, perhaps even regarding him as a forerunner of the Impressionists. The Impressionists' approach to landscape was diametrically opposed to Canaletto's rational approach. While the Impressionist painter is wholly aware of the inevitable transformations caused by the atmosphere between the eye and the object, and indeed tries to capture this constantly changing aspect of reality, Canaletto, as an eighteenth-century painter, does just the opposite. He does away with atmosphere and glorifies the power of light, so that he can rationally and even scientifically control the world, unifying it, not by light together with atmosphere, but by light alone.

This approach is quite reconcilable with Canaletto's use of the *camera obscura*. We know from contemporaries that Canaletto frequently had recourse to this device. Since the Impressionists, we have come to think of the landscape artist as painting in the open direct from nature, recording things as he sees them, and it is disconcerting, even disappointing to imagine Canaletto, wandering through the narrow streets and little squares of Venice with the trestles for the *camera obscura* on his back. Half-hidden under the dark canopy, rather like a nineteenth-century photographer, he used this arrangement of mirrors and convex lenses to trace the view reflected on the paper placed at the focus of the lens. Yet these mechanical

sketches, impersonal records of reality which are only the raw material of art, were necessary to Canaletto. They were like a guarantee, a scientific starting-point for his accurate but poetic artistry. This use of the *camera obscura* can perhaps tell us more clearly than anything else what having a visual hold on reality meant to Canaletto, man of the Enlightenment and poet of rational, verifiable certainties.

From 1730 onwards, Canaletto was painting exclusively for English tourists, and eventually the bulk of his output passed through the hands of Joseph Smith, an Englishman living in Venice. Joseph Smith was an unusual personality, something of an adventurer, but also an intellectual and a discerning art collector; above all he was a very clever businessman. He settled in Venice in the early years of the eighteenth century, and made his fortune, apparently through some rather dubious dealings in imported meat and fish. He became a collector, publisher and art dealer, and in 1744 was appointed His Britannic Majesty's Consul to the Serene Republic of Venice. For many years Smith was a leading figure in the intellectual life of the city, and he was virtually responsible for the choice of paintings to be exported to England. He was one of the first people to appreciate Canaletto's talent. He monopolized, perhaps even supervised his output, and launched him in Britain, where he created a solid market for his work.

Whatever the personal relationship between Smith and Canaletto may have been, the interesting point is that Canaletto was very much in the position of a present-day artist. Isolated from his public, with which he rarely had any direct contact, keeping an eye on the fluctuations of the art market, which was dominated by critics and dealers who controlled information, publicity and sales, Canaletto's situation was already that of the bourgeois artist within capitalist society. It had certain advantages – prestige, payment, rationalized production – but entailed restrictions, frustration and conformity to the system. There is no doubt that Joseph Smith exploited Canaletto (Horace Walpole, who referred to his enterprising compatriot as the ' merchant of Venice ', testifies to this) and there is no doubt that Canaletto knew

it. But there was no way out. Canaletto specialized in a genre which was in demand mainly abroad, and he could not do without Smith. Although he sometimes showed signs of dissatisfaction with his patron, he continued to turn out views for him and his clients with clockwork regularity.

These were certainly his most productive years. He worked ceaselessly, weighed down with orders, helped no doubt by numerous assistants (including from 1738 his nephew Bernardo Bellotto) but always maintaining and improving on his own high standards. His works in the 1730s include the series of twenty-four Venetian views painted for the fourth Duke of Bedford (*pls 43-6*), the *Entrance to the Grand Canal, looking west* (*pls 47-8*) now in Houston, *The Molo looking west: the Fonteghetto della Farina* (*pls 49-51*), one of the few works by Canaletto to remain in Venice, the *Regatta on the Grand Canal* (*pls 52-5*) now at Windsor Castle, the *Ducal Palace from the Bacino di S. Marco* (*pls 59-61*) in the Uffizi, and the *S. Giuseppe di Castello* (*pls 62-4*) *and SS. Apostoli: Church and Campo* (*pls 65-6*) now in private collections in Milan.

Canaletto brought the same calm and clarity of mind to all his work in this prolific period. He paints the multifarious facets of the city with the same limpid luminosity, and the same unwavering, restrained but poetic vision. Look at his *Campo Sta Maria Formosa* (*pls 43-6*), for example, bathed in the noonday sun: it could be the bright stage for one of Goldoni's witty, sophisticated plays. Or the *Entrance to the Grand Canal, looking west*: the water is green and brilliant in the cold light, with the gondolas and rowing boats jostling each other in the foreground, and in the distance, beyond the boats, one can still clearly see the palaces and houses along the canal, shimmering against the cloudy sky. Or the festivals of Venice, the regattas and the ducal processions, the lavish spectacles, when the palaces are bright with bunting and flags, and the noble citizens don their cloaks and dominoes, and the city has the surreal, slightly macabre look of the eighteenth-century carnival. Canaletto also paints the lesser-known parts of the city (the Scuola di San Rocco, the Campo SS. Apostoli) and there are still some

glimpses of the popular quarters of Venice, which have an almost nineteenth century flavour. I have in mind the fine view of the Sestiere district between the churches of San Niccolò and San Giuseppe, where the grassy terrain is littered with rubble and building materials, and the anonymous dwellings on the left-hand side, grey and pink in the neutral light, are reminiscent of buildings in a modern suburb. Such was the city which Canaletto observed, and which he painted to adorn the distant homes of English gentlemen.

Soon Canaletto himself was to set sail for England where he planned to meet his clients in person. However, before we go on to discuss his stay in London, we should draw attention to some of Canaletto's major works in this period: the two views in Washington, for example, (*pls 75-82*), the *Piazza S. Marco, looking west along the Central Line* (*pls 83-4*) in Detroit, the splendid *Bacino di S. Marco, looking east* (*pls 72-4*) in Boston, and above all *The Doge visiting the Church and Scuola di S. Rocco* (*pls 67-71*) in the National Gallery, London. All these paintings date from around 1735 or soon afterwards.

The Doge visiting the Church and Scuola di S. Rocco (*pls 67-71*) depicts the annual visit of the Doge to the confraternity of St Roch, the miracle-working saint, on 16 August each year when painters exhibit their works out of doors. It is remarkable among Canaletto's works because he departs from his usual subject matter, the better-known parts of Venice, to paint a colourful local festival. The whole of Venice in the time of the last Doges seems to be assembled here in the church square: the Doge (Alvise Pisani, perhaps), in yellow and ermine robes, the Procurators of St Mark, resplendent in their white wigs and scarlet robes of office, the women in their dazzling white veils, solid citizens in tricorne hats, noblemen wearing their swords, labourers taking a break from their work, women leaning from the windows, where gaily coloured drapery billows in the summer breeze. The lighter tones – the whites, reds, brilliant yellows, soft greens and ice blues – blend perfectly with the velvety dark tones, and there is that penetrating, gently ironic observation of people and

social classes, which Pietro Longhi was soon to admire.

The *Bacino di San Marco (pls 72-4)* is perhaps Canaletto's masterpiece. As Zampetti has remarked, this painting calls to mind modern photographic and cinematic techniques, like the wide-angle lens and Cinerama. The artist sees Venice, from San Marco to the Punta della Giudecca, unfold before him. But the city, seen from above, only occupies a proportionally small part of the canvas, and is a thin strip between the high horizon and the mirror-like lagoon. Canaletto dispenses with his traditional perspective ' wings ' and loses himself in the landscape. Venice emerges out of the sea, as if seen through the window of an aeroplane coming in to land: first, in the foreground, the boats in pairs in the green water, with their black hulls and their rigging shining in the sun; then the big ocean-going ships, warships and cargo boats, with their different flags, moored in the deepest water; then the smaller vessels, their hulls and masts crammed together along the jetties; and in the distance, Venice, a narrow strip, where sky and sea meet, concealed behind the bustle of the port, so that one can barely make out the towers of the famous churches from the top-sail yards of the farthest ships. In this work, Canaletto has captured for posterity the humming, golden bustle of a Mediterranean port. Every detail, sometimes no more than a speck of light or dazzling fragment, makes its own essential contribution to the sunlit scene, from the far-off galley to the fishing-boat by the island of San Giorgio, from the brilliant whiteness of a slackened sail to the prow of a gondola, from the gentleman's tricorne hat to the sailor's shirt.

In 1746 Canaletto left Venice for England, where he was to spend more than ten years. This was certainly the most important event in Canaletto's career, and one may well ask what led him, at the age of fifty, to take such a step. Canaletto was notoriously retiring and unadventurous, and had previously only left Venice as a young man to go to Rome, and had probably made a further visit to Rome later on, although this second journey is not well-documented. The wish to end his connection with Smith and to meet his foreign clients in person may have played a part in his decision. However, as his English contemporary,

Vertue, somewhat cynically pointed out, it was probably the War of the Austrian Succession and the standstill in the Venetian art market that prompted him to undertake this hazardous journey into the unknown. Like his Venetian contemporaries, Marco Ricci, Tiepolo, Pellegrini, and Bellotto, Canaletto went abroad in search of commissions which were in short supply at home.

By the eighteenth century, Venice was no longer a rich city. Maritime trade was stagnating; the great noble families of Venice were investing their still considerable fortunes in land and were living off the rents. The problems of a dwindling and pauperized population were assuming alarming proportions, while tourism, a new industry which offered the *élites* of Europe the glories of the past and the more prosaic diversions of the present, was becoming the main economic prop of the declining republic. As a result, the artistic market, one of the few remaining active sectors of the economy, underwent a radical change. Those bodies which had been the main source of commissions – the church, the oligarchical government, the guilds – had lost much of their former importance in the general economic and political decline. It was now the tourists and the dealers who set the prices, and who directly or indirectly influenced the critics. The position of the artist, who had to adapt his output to the requirements of foreign clients, and often had to follow them all over Europe, from St Petersburg to Madrid, from London to Warsaw, became increasingly precarious and insecure. On the other hand, at the same time Venetian art benefited from these contacts and influences, acquired a more European character, and attained an even higher level. The example of eighteenth-century Venice shows how little truth there is in the view that art and culture must automatically follow economic history.

In London, Canaletto did not find the universal acclaim that he had probably expected. He could count on important and reliable clients, he had influential patrons, he could sell his work easily, but for all that it was hard to win over the English public. There was even conjecture, so Vertue tells us, as to whether the visiting Italian artist was really the famous Venetian Canaletto, and to put a stop to this,

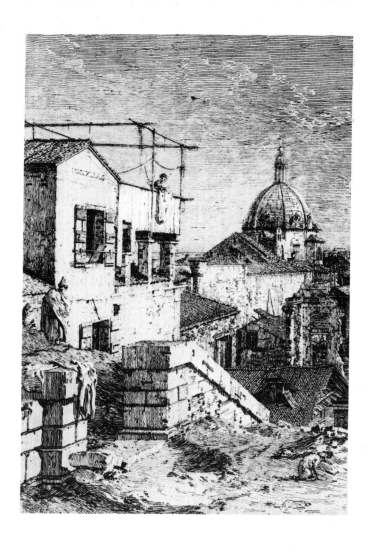

'*Capriccio*' *with memories of Venice and Rome. Signed and dated: 1741, A.C. (etching for the 1744 volume).*

Canaletto had to advertise in newspapers and invite the public to his studio. The fact is that the views Canaletto painted in London were not as popular as the views he painted in Venice and then sent abroad. To this day the work of Canaletto's English period tends to be underrated, by Anglo-Saxon critics at least. Even Constable, the leading expert on Canaletto, is inclined to underestimate the English views in his recent important monograph. He accuses Canaletto of arbitrarily Italianizing London, as if he had tried to bring the light of the Bacino di San Marco to the Thames.

In my opinion, however, the paintings of this English period represent a further step forward in Canaletto's artistic career. Certainly the Thames is a far cry from the San Marco basin. The blue of the English sky is very different from the blue of southern skies, and the layout of London itself, already an expanding industrial city, has little in common with the Venetian townscape. Canaletto was perfectly aware of all this, and as a result, no sooner had he arrived in London than his style underwent a radical change. So much so that his clients were baffled, and some of them even doubted his identity.

The light in England was smoother, more uniform and colder than in Italy, and its effect was to soften shadows and blur contrasts. Canaletto deliberately reduced his scale of colours, and based his views on a few dominant colours: liquid greens, straw yellows and smokey blues. The English landscape did not have the historical density, the close concentration of humanity and culture, of the Italian landscape. There were few famous monuments which could be singled out in a painting, few areas in the city which could be easily identified by the tourist. England demanded a broader approach, which would embrace the interpenetration of town and country, the structure of its towns and even of its social make-up. Thus Canaletto altered his means of expression and even his approach to reality. He did away with the now redundant perspective 'wings', broadened the angle of vision so as to emphasize the characteristics of the English landscape: the lawns, the gentle rolling countryside, the huge scale and functional structure of the build-in the cities.

In the view of *London: the Thames and the City of London from Richmond House (pl. 88)*, painted in 1746 immediately after his arrival in London, Canaletto reminds us of the *Bacino di San Marco (pls 72-4)*: the city is seen in profile between the estuary and the sky, but without the golden bustle of the Mediterranean port. Here London is displayed, set back from the river, clear and rather severe, around the cupola of St Paul's. The simple lines of the terraces in the foreground seem to echo the rational, bourgeois mental climate of the city. In the fine view of St James's Park, painted in 1749, the artist is less concerned with the individual buildings, which are not in themselves especially interesting, than with that neat, typically British model of urban planning, the city park. This is why the view opens out in all directions, the buildings are kept discreetly in the background, and the main body of the picture is filled by expanses of lawn, and broad avenues where solid London citizens peaceably stroll. Even in a picture like *Westminster Abbey with a procession of Knights of the Bath (pls 89-90)*, in which Canaletto is concerned with a single famous building and its historical and cultural associations, at the same time he appreciates the shades of ritualized deference and polite irony in the English attitude to tradition. The impeccable and anachronistic array of benign gentlemen assembled in the sacristy of the Abbey, who seem to be borne along, as in a naive painting, rather than move themselves, could only have been painted by someone with a genuine understanding of English customs, culture and mentality.

Canaletto sensed the already pre-romantic feelings that the English middle-classes were beginning to harbour for the countryside, and he captures the romantic quality of the country in some fine paintings which seem to anticipate Constable and Corot. In the paintings of *Alnwick Castle, Badminton Park* and *Walton Bridge*, painted in 1754 (*pls 91-3*), he paints a tangled tracery of glowing lines beneath a cloudy sky, in a dappled, fluid country landscape.

He was also interested in the changes, on an industrial scale, that were affecting London at the time. He was, for example, particularly interested in Westminster Bridge, then

nearing completion. His views of the bridge look rather like technical studies; they show the impact of this construction on the urban landscape, and even its structural features. There is one view taken from water-level, at the base of the piers, and another one looking at London through one of the arches still encased in scaffolding.

Canaletto also paints views that hint at the beginnings of the Gothic revival: *Warwick Castle*, a complex structure of turrets and chimney tops, of buttresses and recesses, embrasures and windows, and clear light falling on the soft green lawns; *Eton College Chapel (pls 97-101)* rising in the distance against the uneven line of the town on the far bank of the river, with trees in full leaf in the foreground. During the ten years he spent in England, Canaletto tried to penetrate and portray the spirit, culture and civilization of his host country. Perhaps, he did not always entirely succeed, but there is no doubt that Canaletto has left an incomparably faithful and unbiased pictorial account of eighteenth-century England. With the work of his English period, Canaletto became a truly 'European' artist, anticipating his nephew, Bellotto, who was to visit Germany and Poland, in bringing the Italian 'view from nature' not only to the physical, but also to the cultural and social map of Europe. There is no need to underline the importance for the modern history of art of this broadening of horizons, begun by Canaletto and completed by Bellotto.

Canaletto's stylistic development virtually comes to an end with the close of this English period. He was already in his sixties when he returned to Venice in 1756. Before his death eleven years later, he was to be honoured by the Accademia in 1763, though not without some opposition. But his last paintings, the *Capriccio: a colonnade opening on to the courtyard of a palace (pls 106-7)*, in the Accademia in Venice, and the *Piazza S. Marco: looking east from the south-west corner (pls 102-3)*, can add little to our appreciation of Canaletto. These last works tend to be mechanical, academic (the Accademia had appointed him professor of perspective) and rather unconvincing.

Truer to Canaletto are the words written in a fine and steady hand, two years before his death, on the side of

a drawing now in the Kunsthalle in Hamburg. He signs the drawing 'Zuane Antonio da Canal', adding 'at the age of sixty-eight, done without spectacles'. It is all the more moving to remember that the author of these humble yet proud words had observed a whole epoch and has left us its matchlessly clear and splendid image.

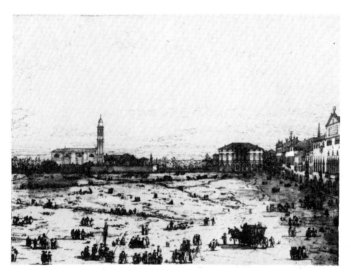

Panoramic view of Pra' della Valle. Drawing for an etching. Windsor Castle, collection of Her Majesty the Queen.

Drawings and Engravings

No study of Canaletto would be complete without some mention of his graphic art. Canaletto's abundant drawings, nearly all of which are very fine and highly expressive, throw much valuable light on his approach and methods. (The album, formerly belonging to Guido Cagnola, and now in the Accademia in Venice, is of exceptional interest.) But it is in his magnificent series of etchings that he reveals his true genius as a graphic artist. His thirty-one etchings, collected in a volume in 1744 and dedicated to Joseph Smith, mark out Canaletto as possibly the greatest eighteenth-century engraver, comparable only to Giovan Battista Piranesi in his skill and powers of expression as a graphic artist. He uses a very light touch, almost without cross-hatching, so that the light material can glide freely through the gently curving sections of the engraving. The images stand out with extraordinary clarity (as, in particular, in the superb *Torre di Marghera*) while the sun, as Pittaluga notes ' never quite dispels the light veil of the atmosphere '. Thus Canaletto's greatness as an engraver lies in his ability to define clearly while yet retaining in his engravings the immediacy and expressiveness of the sketch.

See pages 13, 15, 23, 27, 35.

Canaletto and the Critics

Critical assessments of Canaletto reflect the broad changes in outlook and taste in Europe from the Enlightenment to the present day. In the eighteenth century Canaletto's work was very highly regarded, and his great commercial success bears witness to this. Critics like Zanetti, and refined intellectuals like Charles des Brosses and Algarotti, were lavish in their praise of Canaletto, and the sensual and rationalist cultural *élite* of the time, hungering for objective certainties, found their aesthetic ideal embodied in his work.

Romanticism, which rejected the search for objective truth of the Enlightenment, accused Canaletto of being dry and mechanical in approach, of lacking imagination and of being flatly realistic. The severest, most paradoxical and most brilliant attack on Canaletto was made by John Ruskin (*Modern Painters*, 1843-60), leader of the Gothic revival, critic of industrial society and of middle-class lay rationalism. The success of Impressionism did nothing to re-establish Canaletto's reputation. In fact, it led to a reappraisal of Francesco Guardi, and a reassessment of Venetian eighteenth-century art, which assigned an inferior role to Canaletto.

For an appreciation of Canaletto's art in the nineteenth century, we must look not to official critics but to the more independent judgement of painters: Turner, for example, had a great admiration for Canaletto, Whistler compared him to Velázquez, and Manet, too, is known to have admired him.

In the twentieth century Canaletto's reputation has risen ever more rapidly. Damerini (1912) and Fiocco (1929) still overrated Guardi, at Canaletto's expense; but Pittaluga (in *L'Arte*, 1934) led the way towards an objective and complete reassessment of Canaletto. Since the Second World War the last remaining doubts about Canaletto's true status have been eliminated by the work of such critics as V. Moschini (*Canaletto*, Milan 1954, London 1956) and W. G. Constable (*Canaletto*, Oxford 1962), and by the major exhi-

bitions in Turin (1964) and Venice (1967). There is a useful article by F. J. Watson in the McGraw-Hill *Encyclopedia of World Art* (vol. 3, London and New York 1960); for full bibliographical information see Moschini and Constable. The criticism of the last twenty years has restored Canaletto to his position among the greatest eighteenth-century painters.

Notes on the Plates

1-4 Capriccio: Ruins, 1723. Oil on canvas, 180×325 cm. Milan, private collection. Signed and dated ' IO ANTONIO CANAL 1723 '. This work, which still shows the influence of stage design, was brought to light by Morassi (1963).

5-7 Grand Canal: looking north-east from the Palazzo Balbi to the Rialto Bridge, 1723. Oil on canvas, 143×200 cm. Milan, Crespi collection. One of four canvases which formerly belonged to the princely family of Liechtenstein, and which date from 1723. Although there are still traces of the theatre designer's approach, with these works Canaletto can now be said to have become a *veduta* painter.

8-9 Rio dei Mendicanti, 1723. Oil on canvas, 143×200 cm. Milan, Crespi collection. This work was painted as a pendant to the preceding work and dates from the same time. This is one of the greatest of Canaletto's early works. It is obviously inspired by the Caravaggesque naturalism to which Canaletto had been introduced through the work of Viviano Codazzi, Agostino Tassi etc.

10-11 SS. Giovanni e Paolo and the Scuola di S. Marco, c. 1725-6. Oil on canvas, 125×165 cm. Dresden, Gemäldegalerie. This very fine painting is a replica of one of the four views painted for Stefano Conti of Lucca between 1725 and 1726. We see here how the luministic agitation of Canaletto's early works, gradually gives way to an increasingly even and thoughtful manner.

12-13 Entrance to the Grand Canal, looking east, c. 1725-6. Dresden, Gemäldegalerie. This work may be grouped chronologically and stylistically with the preceding work and the Conti views.

14-15 Campo S. Giacometto, c. 1726-7. Oil on canvas, 95.5×117 cm. Dresden, Gemäldegalerie. The subject of this painting is a lesser known corner of Venice, and its daily life. It is very close to the group of paintings now in the Pillow collection in Montreal, and dates from the end of the 1720s, around 1726-7.

16-17 Bacino di S. Marco, looking north, c. 1726. Oil on canvas, 141×152.5 cm. Cardiff, National Museum of Wales. The vastness of the panorama, which stretches from the Dogana to the Palazzo Ducale and the Palazzo Dandolo, might suggest a later date for this work, but the strong chiaroscuro contrasts, which are typical of Canaletto's early work, give credence to the date suggested by Zampetti, around 1726.

18-21 Dolo on the Brenta, c. 1725-30. Oil on canvas, 63×97 cm. Oxford, Ashmolean Museum. The work dates from the late 1720s, and, together with the following work, marks the height, and perhaps, the close, of Canaletto's attempts to give a clear and sensitive rendering of objective truth.

22-5 Grand Canal: The Stonemason's Yard; Sta Maria della Carità from across the Grand Canal, 1726-7. Oil on canvas, 141×152.5 cm. London, National Gallery. The date is most probably, as Pallucchini has suggested, between 1726 and 1727. This work is generally held to be one of the most important masterpieces of Canaletto's early career.

26-8 Grand Canal, looking north-east from the Palazzo Balbi to the Rialto Bridge, c. 1725-30. Oil on canvas, 45×73 cm. Florence, Uffizi. The thick impasto and the striking contrast of light and shade suggest that this is an early work, probably in the late 1720s.

29-31 Reception of the Imperial Ambassador, Count Giuseppe di Bologna, at the Palazzo Ducale, 1729. Oil on canvas, 184×. 259 cm. Milan, Crespi collection. See note to *pls 32-5*

32-5 The Bucintoro returning to the Molo on Ascension Day, 1729. Oil on canvas, 182×259 cm. Milan, Crespi collection. Companion piece to *pls 29-31*. Although, particularly in the first painting, Canaletto has obviously drawn on official compositions by Luca Carlevaris, the two works mark the attainment of Canaletto's expressive and highly original artistic maturity. By the end of the 1720s (and these paintings were certainly painted in the spring and summer of 1729) Canaletto, following the general trend in Venetian art of the period, had already lightened his palette.

36 The Dogana and the Giudecca Canal, c. 1729-30. Oil on canvas, 46×61 cm. Milan, Crespi collection. One of an important series of views which formerly belonged to Prince Joseph Wenceslaus Liechtenstein, and which date from 1729-30. The exceptionally strong visual grasp of reality, the clarity of the perspective, and the brilliant midday sunlight, are typical of the mature Canaletto of this period.

37-9 The Quay of the Dogana, 1729-30. Oil on canvas, 46×62.5 cm. Vienna, Kunsthistorisches Museum. The work may be grouped chronologically and stylistically with the preceding work.

40-2 Riva degli Schiavoni, looking west, c. 1730. Oil on canvas, 46×62.5 cm. Vienna, Kunsthistorisches Museum. This most probably belongs to the Liechtenstein group, which has been reconstructed by Zampetti, and thus dates from 1730. It is the pendant to the preceding work, as Constable has noted.

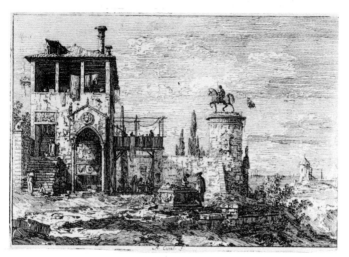

Imaginary view, with ruins (etching for the 1744 volume).

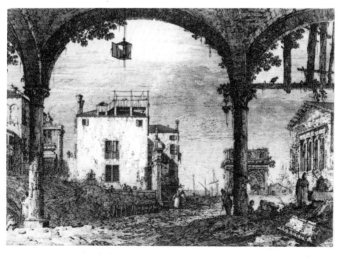

Imaginary view with porch and ruins (etching for the 1744 volume).

43-6 Campo Sta Maria Formosa, c. 1730. Oil on canvas, 47×
80 cm. Woburn Abbey, Duke of Bedford collection. This is one
of twenty-four Venetian views painted by Canaletto around 1730
(when he was already working for Joseph Smith) for the fourth
Duke of Bedford.

47-8 Entrance to the Grand Canal, looking west, 1730. Oil on
canvas, 49.5×72.5 cm. Houston, Museum of Fine Arts. A clear,
crystalline view of the Grand Canal, painted when Canaletto was
experimenting with light.

**49-51 The Molo looking west: the Fonteghetto della Farina,
c. 1735.** Oil on canvas, 66×112 cm. Venice, Giustiniani collection.
This delightful view of one of the unassuming corners of Venice,
is one of the few Canalettos to remain in Venice. Its date has been
the subject of controversy. Va!canover puts it at the end of the
1720s, but Pallucchini puts it, correctly. I think, shortly after 1735.

52-5 A Regatta on the Grand Canal, 1732-5. Oil on canvas,
77×126 cm. Windsor Castle, collection of Her Majesty the Queen.
The ducal arms, on the left-hand side, are those of Carlo Ruzzini,
Doge in 1732-5, and thus the work would have been painted in
between those dates. This is a very lively version of a typical Vene-
tian festival.

56-8 Grand Canal: the Rialto Bridge from the north, 1730-5.
Oil on canvas, 47.5×79.5 cm. Windsor Castle, collection of Her
Majesty the Queen. One of fifteen views engraved by Visentini in
the album published in 1735; the work therefore dates from between
1730 and 1735.

59-61 The Palazzo Ducale from the Bacino di S. Marco, c. 1735.
Oil on canvas, 51×83 cm. Florence, Uffizi. A replica of one of the
paintings in Woburn Abbey (one of the twenty-four views painted
for the Duke of Bedford). The intensity of the light and the greater
scope of the view suggest a slightly later date, around or soon after
1735.

62-4 San Giuseppe di Castello, c. 1730-5. Oil on canvas, 46×77
cm. Milan, private collection. Together with the following view it
comes from a series of twenty-one works formerly in the Harvey
collection in London. The detachment, observation and fondness with
which Canaletto regards all aspects of Venice enable him, in this
painting, to record the most unexpected and humble facets of the
city.

65-6 SS. Apostoli: Church and Campo, c. 1730-5. Oil on can-
vas, 46×77 cm. Milan, private collection. Details. From the same
series as the preceding work, this is another of Canaletto's mature
masterpieces.

67-71 The Doge visiting the Church and Scuola di S. Rocco, c. 1735. Oil on canvas, 147×199 cm. London, National Gallery. The painting shows the traditional visit made by the Doge together with representatives of the Senate and the Government every year on 16 August, the feast day of St Roch. The Doge looks like Alvise Pisani, who was elected in 1735: the work must therefore have been painted after that date.

72-4 The Bacino di S. Marco, looking east, c. 1735-40. Oil on canvas, 125×204 cm. Boston, Museum of Fine Arts. One of the mature Canaletto's greatest masterpieces, its extensive visual span and the disappearance of all traces of theatre design bring it close to the great works of his English period.

75-8 Entrance to the Grand Canal, from the west end of the Molo, c. 1735-40. Oil on canvas, 114.5×153 cm. Washington, National Gallery. It is a pendant to the preceding work, and is also initialled A.C.F. The sharp, crystalline light and the vast perspective scale suggest that it dates from around 1735.

79-82 Piazza S. Marco, looking south-east, c. 1735-40. Oil on canvas, 114.2×153.5 cm. Washington, National Gallery. Together with the preceding work, this painting is one of the best examples of the poetry of Canaletto's art, its fine observation and its intellectual clarity.

83-4 Piazza S. Marco, looking west along the Central Line. Detroit, Institute of Arts.

85-7 Capriccio: the Colleoni Monument, Venice, set among ruins, 1744. Oil on canvas, 107.5×129.5 cm. Windsor Castle, collection of Her Majesty the Queen. Signed and dated, it probably belongs to a group of thirteen *sopraporte*, panels to go over doors, commissioned by Joseph Smith. The *capriccio* was a typically eighteenth-century genre, popularized throughout Italy and Europe by Pannini and Ricci. Canaletto was not particularly fond of it, and this return to the imaginary themes of his youth reflects the wishes of his client, and the purely decorative purpose of the series.

88 London: the Thames and the City of London from Richmond House, 1746. Oil on canvas, 105×117.5 cm. Goodwood, collection of the Duke of Richmond. This fine view from the terrace of Richmond House is generally thought to be one of Canaletto's first English works.

89-90 London: Westminster Abbey with a procession of Knights of the Bath, 1749. Oil on canvas, 99×101 cm. London, Dean and Chapter of Westminster. This ceremony, the investiture of the Knights of the Bath in Henry VII's Chapel, took place on 26 June 1749. This work was thus painted in the summer of that year.

91-3 Old Walton Bridge, c. 1750-5. Oil on canvas, 46.5×75 cm. London, Dulwich College. A fine landscape, which may already be styled ' pre-romantic '; works like this one certainly had an important influence on the development of Constable.

94-6 London: Ranelagh, interior of the Rotunda, 1754. Oil on canvas, 46×75.5 cm. London, National Gallery. This interesting work is one of the few interior views by Canaletto. It is signed and dated.

97-101 Windsor: Eton College Chapel, 1754. Oil on canvas, 81.5×115.5 cm. London, National Gallery. Also signed and dated 1754, this capriccio shows how Canaletto, now an elderly man, had a profound understanding of the sentimental and cultural overtones of the English landscape.

102-3 Piazza S. Marco, looking east from the south-west corner, c. 1756. Oil on canvas, 45×35 cm. London, National Gallery. Painted immediately after Canaletto's return to Venice. The artist seems to be taking a gently ironic look at the worldly group who meet at the famous Café Florian.

104-5 S. Marco: the interior, c. 1755-56. Oil on canvas, 35.2×32.7 cm. Windsor Castle. An interesting view of S. Marco, whose style suggests a late date. The most likely date, as Constable suggests, would seem to be around or soon after 1755-6.

106-7 Capriccio: a colonnade opening on to the courtyard of a palace, 1765. Oil on canvas, 131×93 cm. Venice, Galleria dell'Accademia. Dated two years before his death, Canaletto painted the work on the occasion of his nomination to the Accademia di Pittura in Venice.

Plates

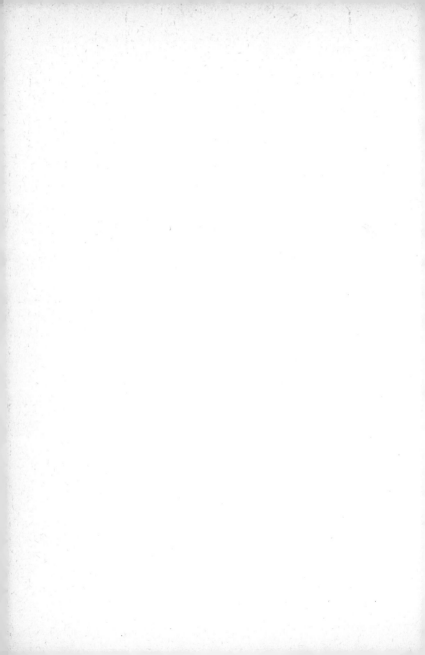

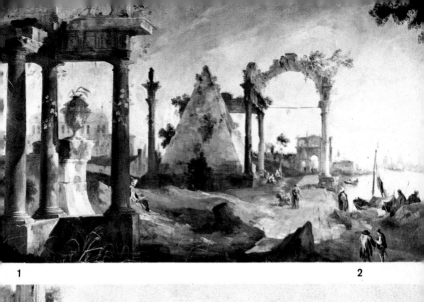

1

2

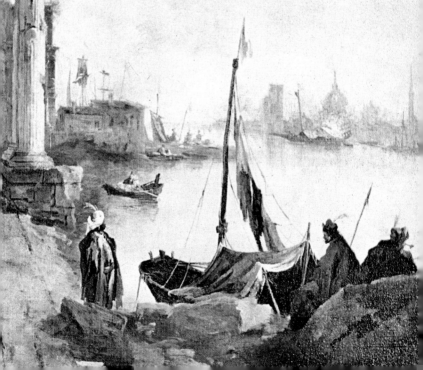

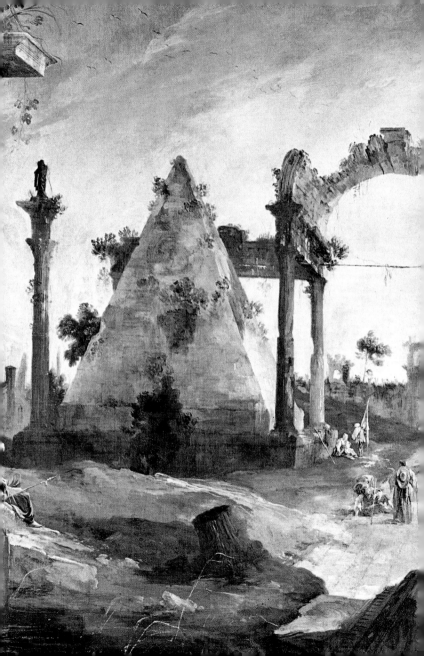

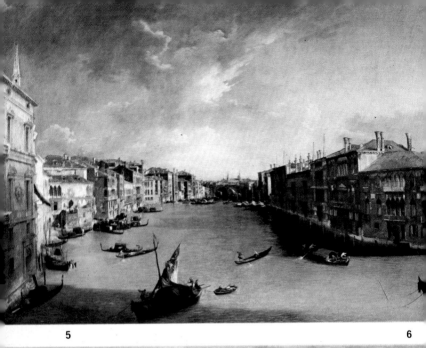

5

6

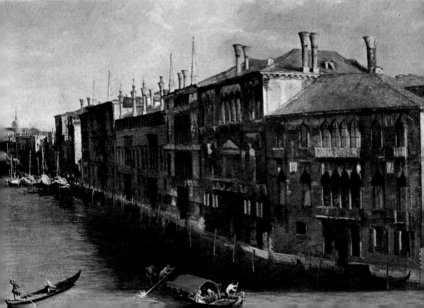

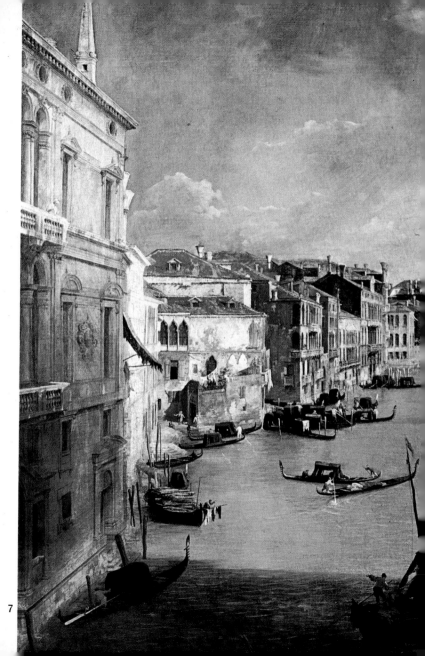

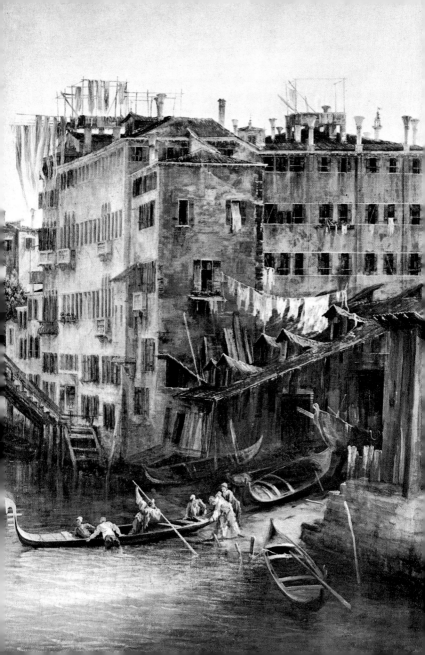

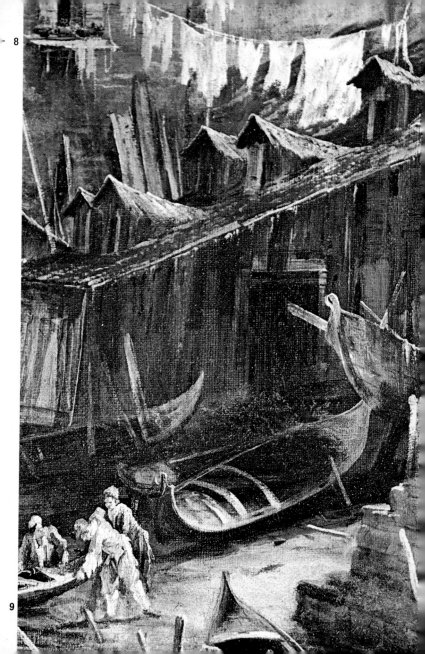

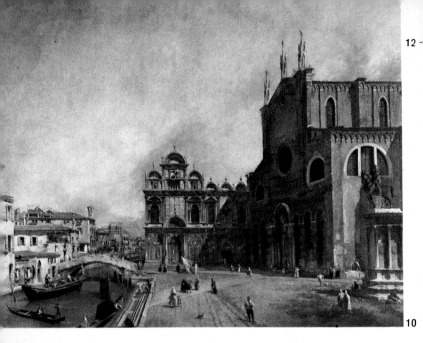

12

10

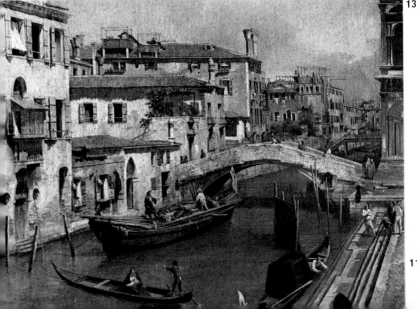

13

11

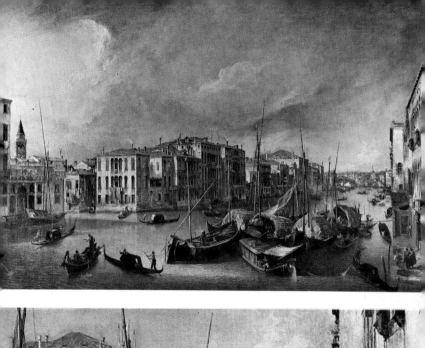

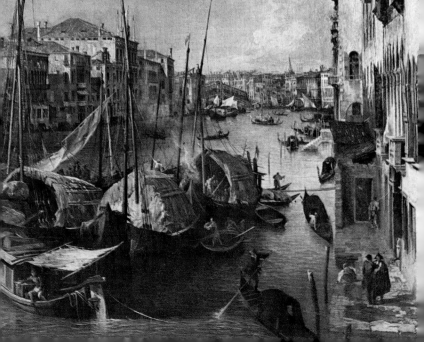

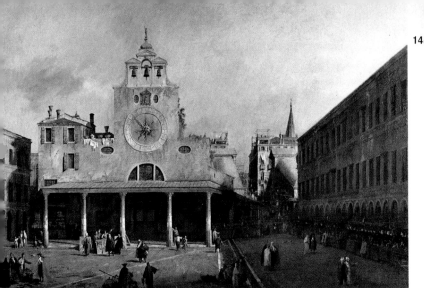

14

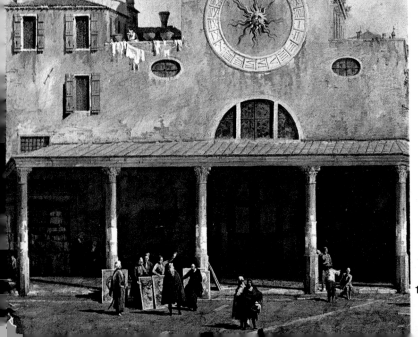

15

16

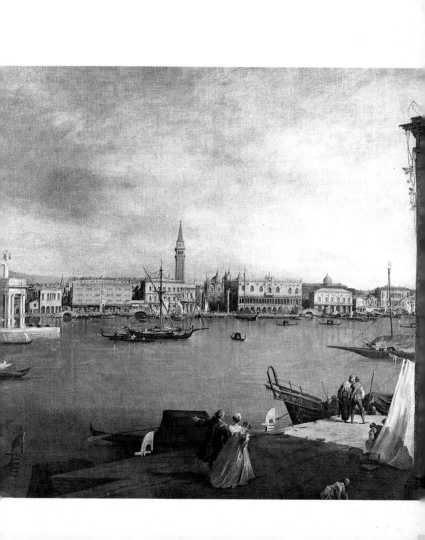

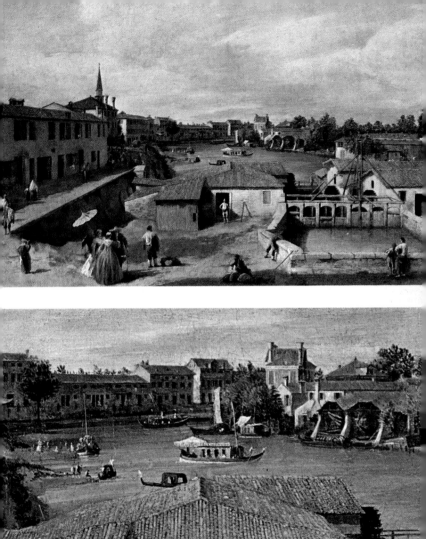
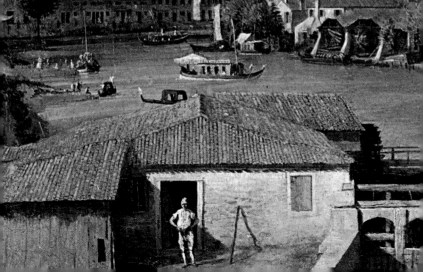

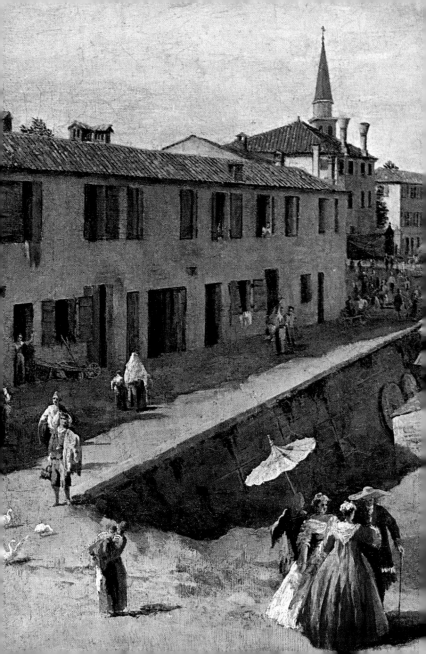

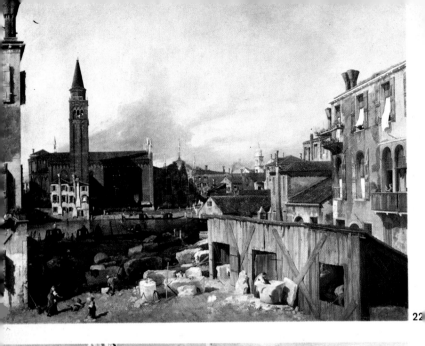

22

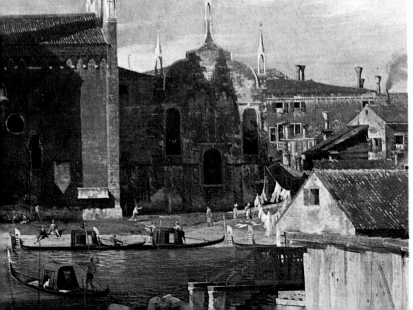

2

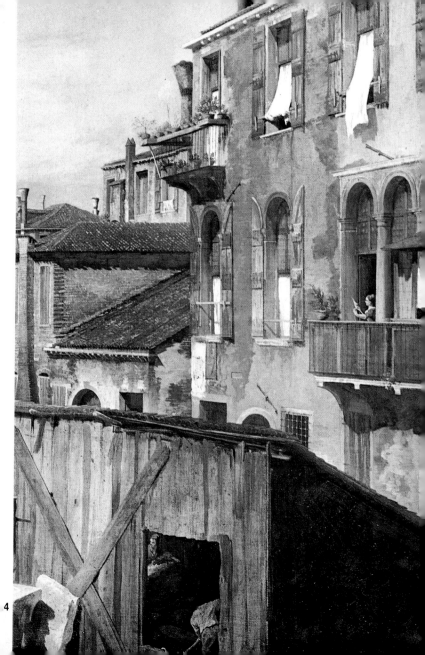

4

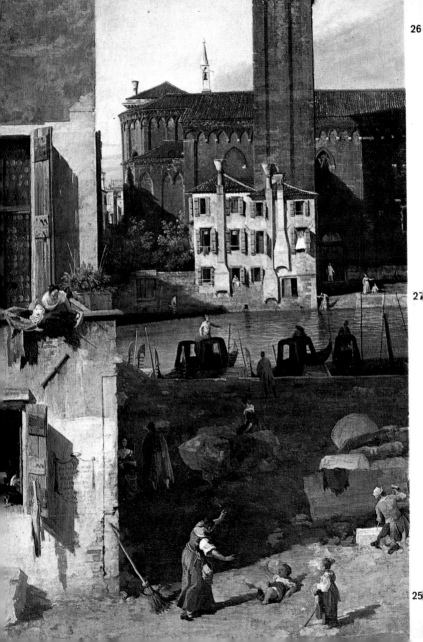

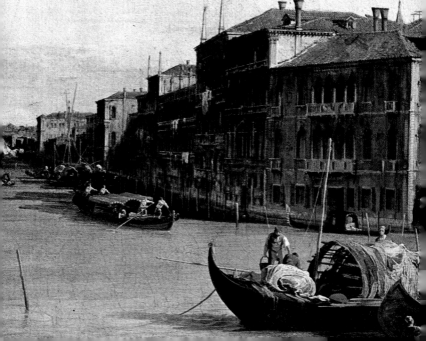

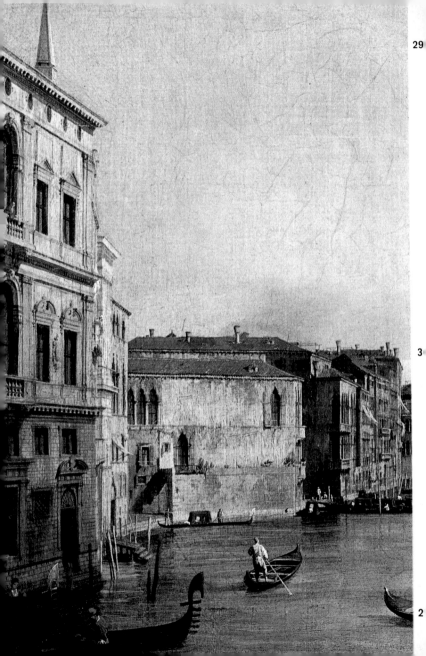

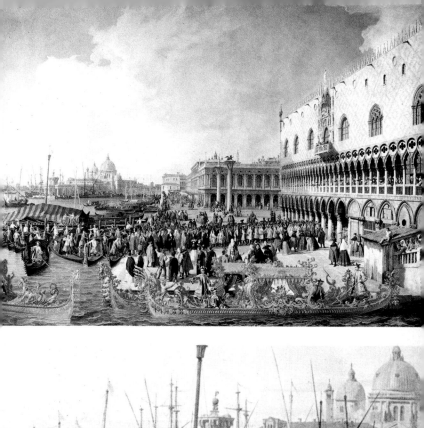

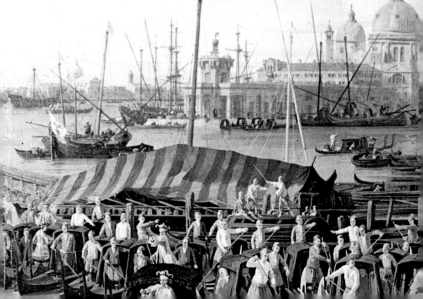

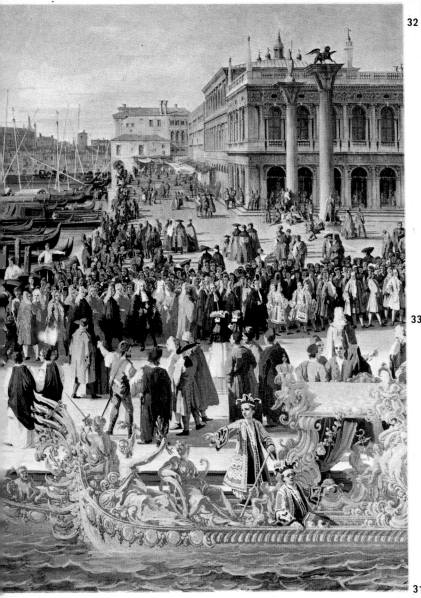

32

33

31

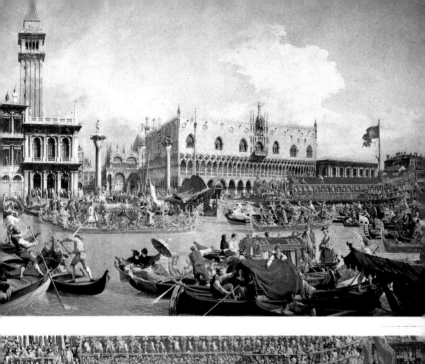
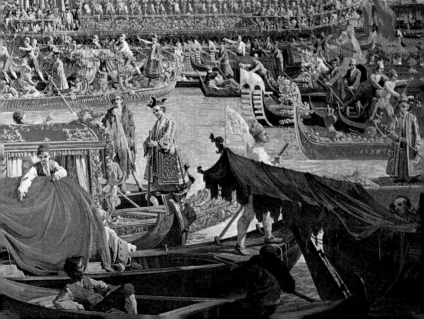

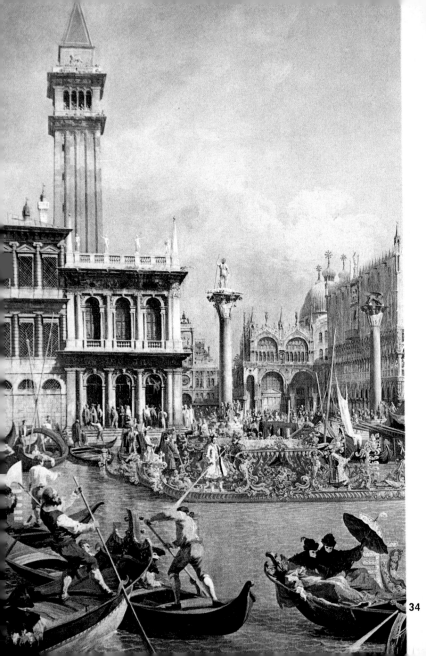

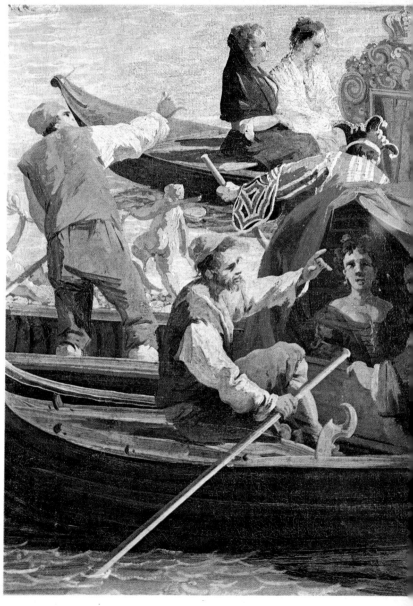

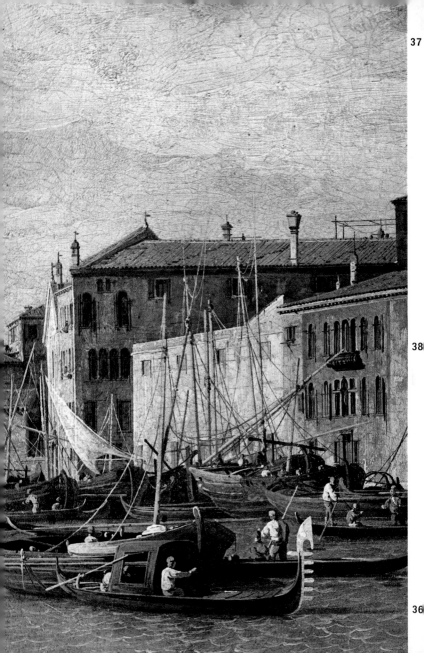

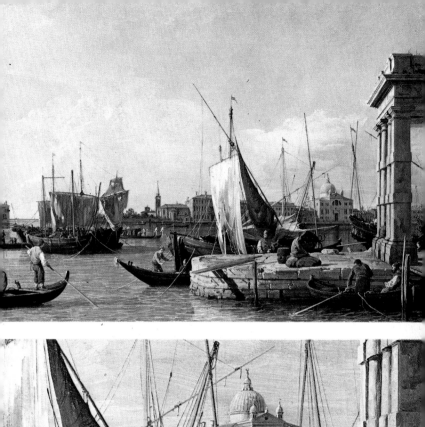

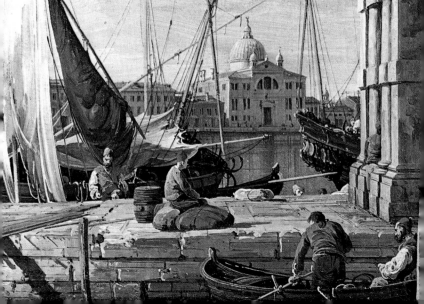

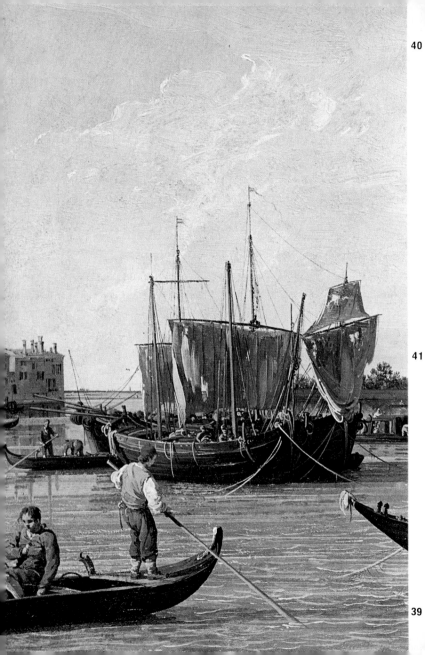

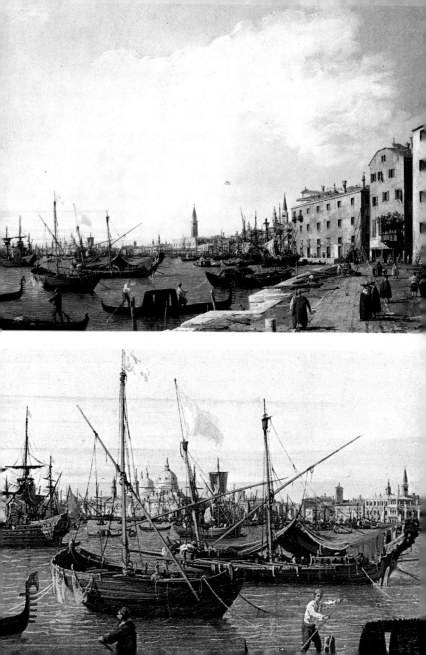

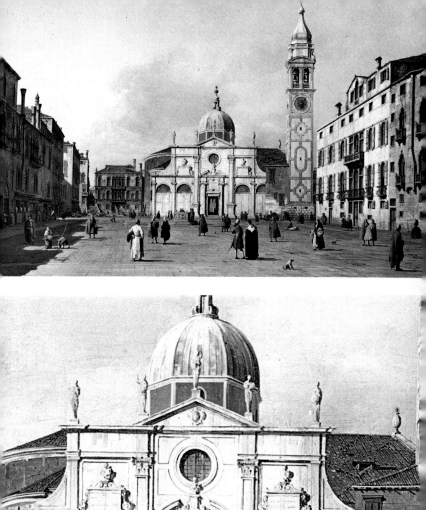

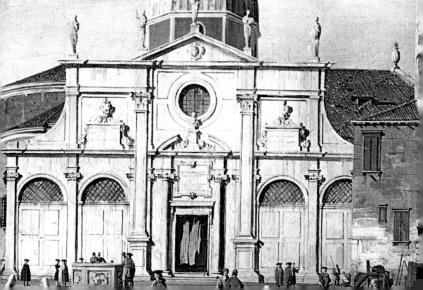

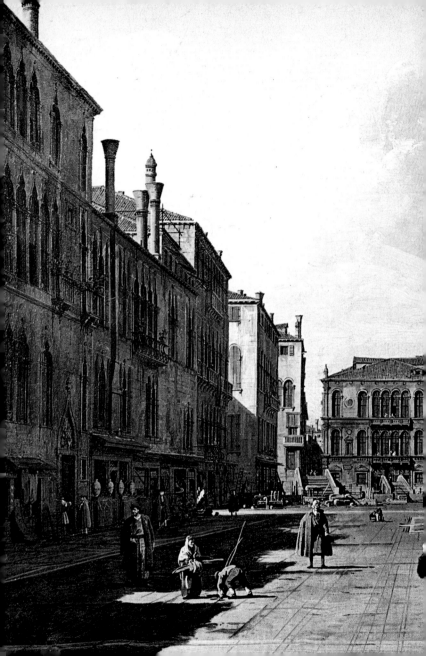

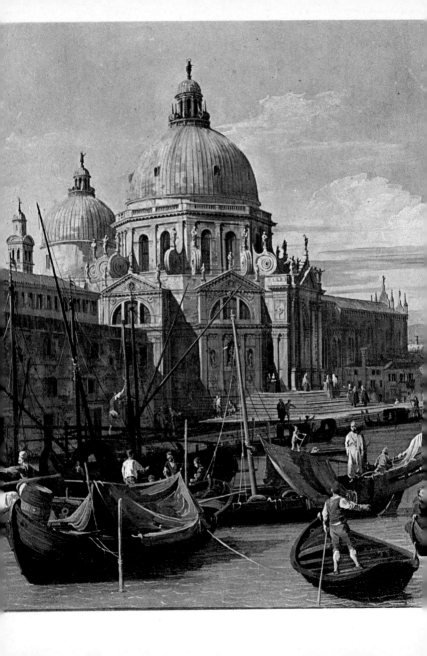

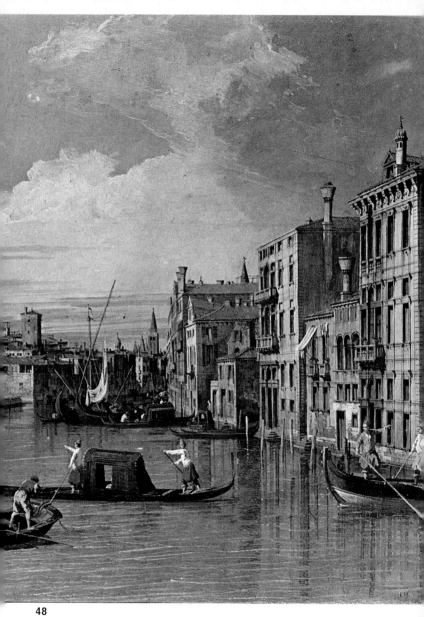

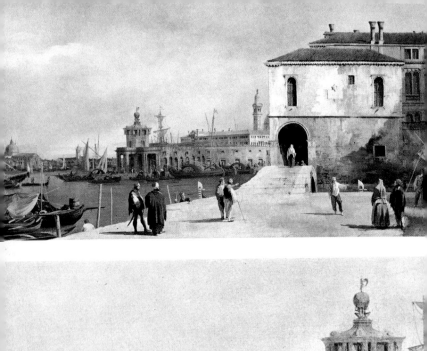

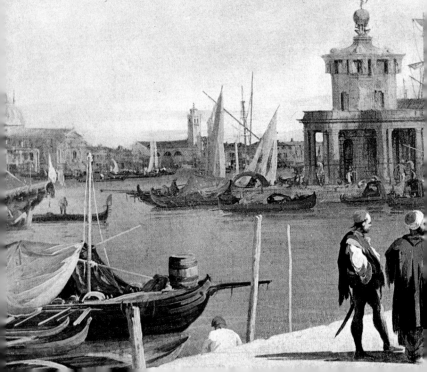

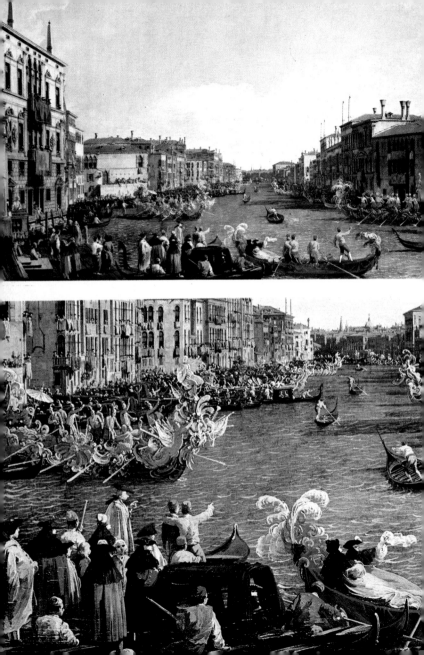

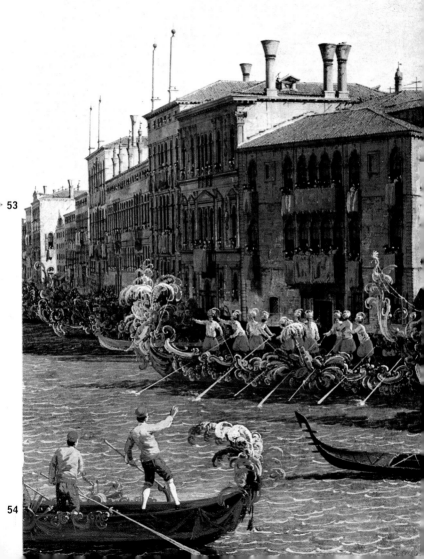

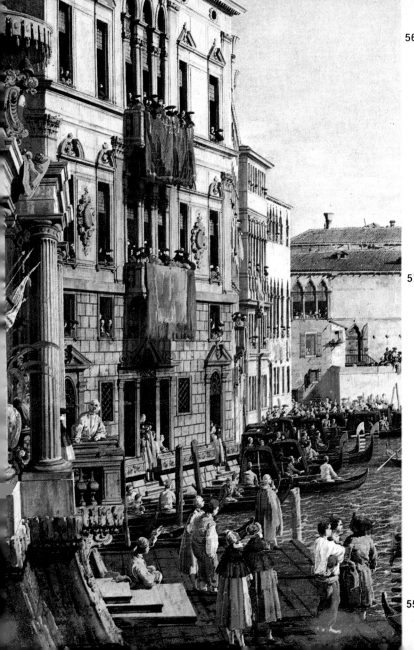

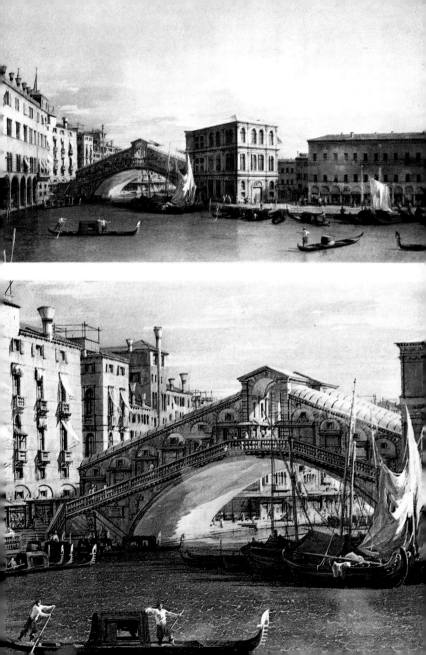

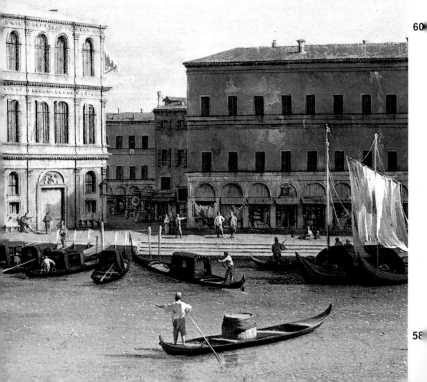

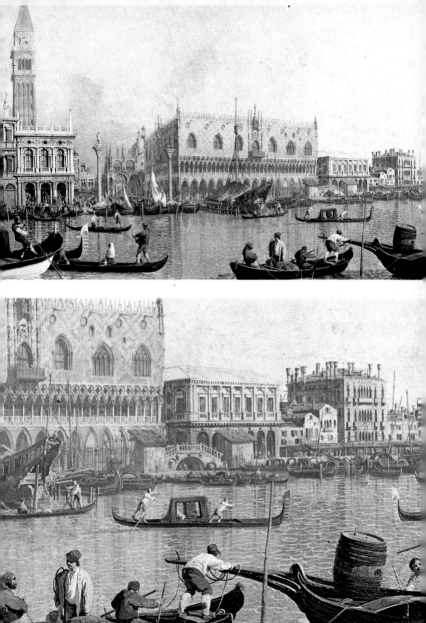

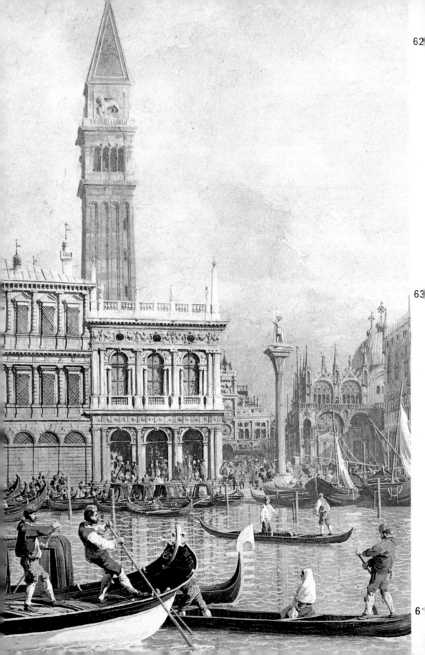

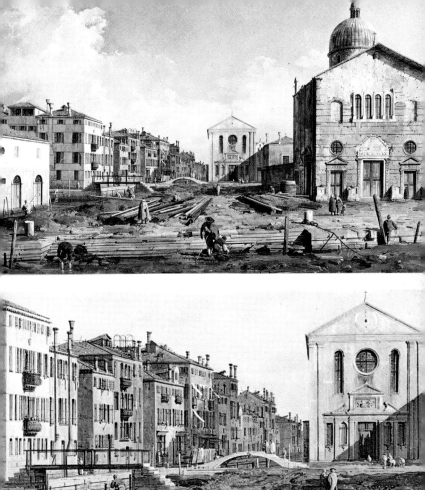
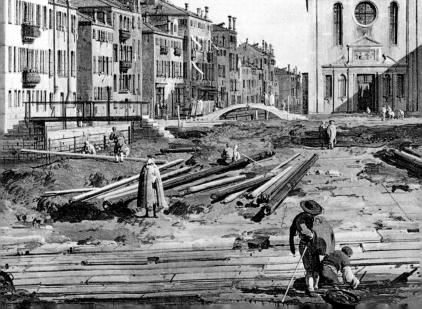

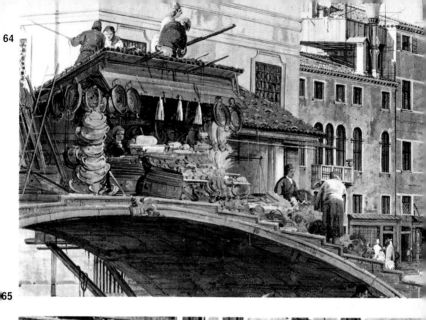

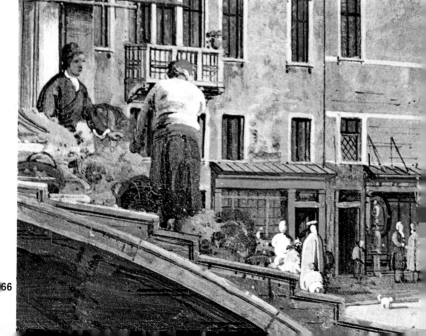

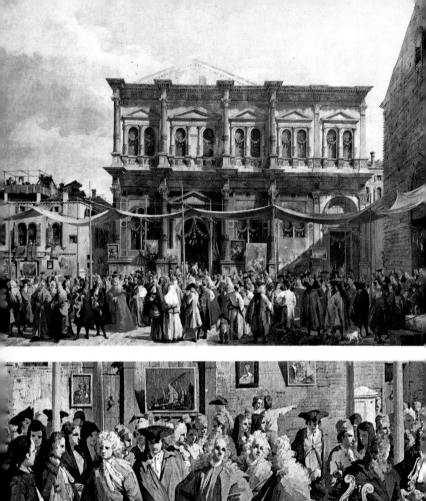
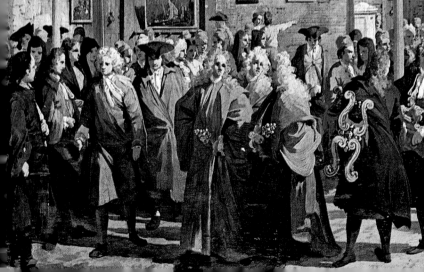

67

68

69

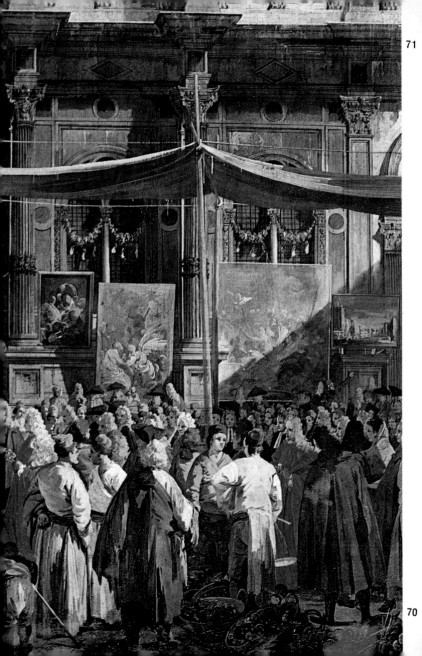

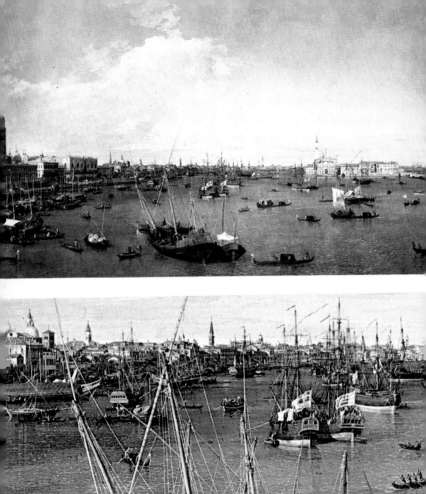
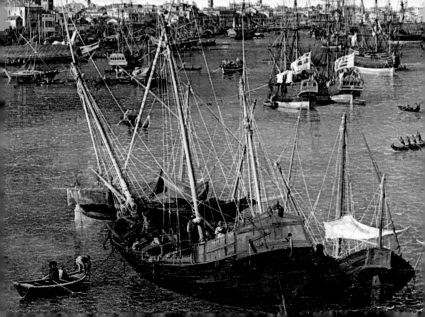

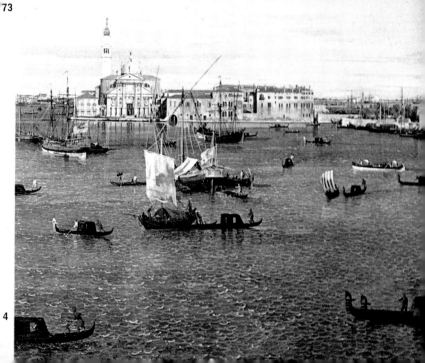

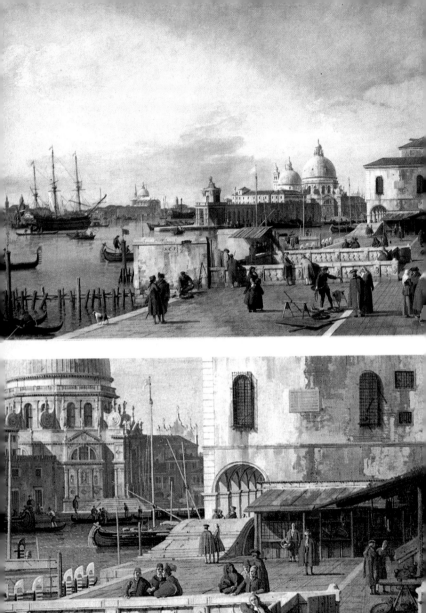

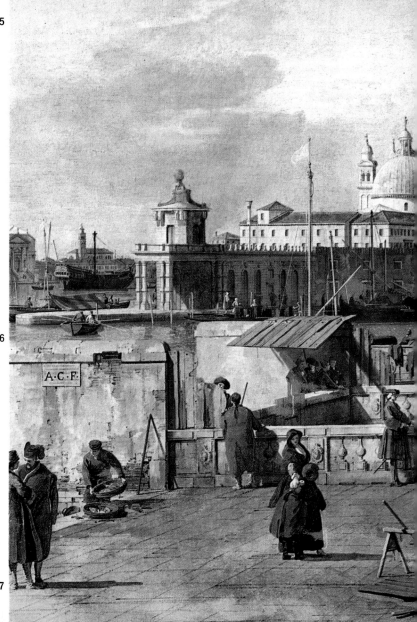

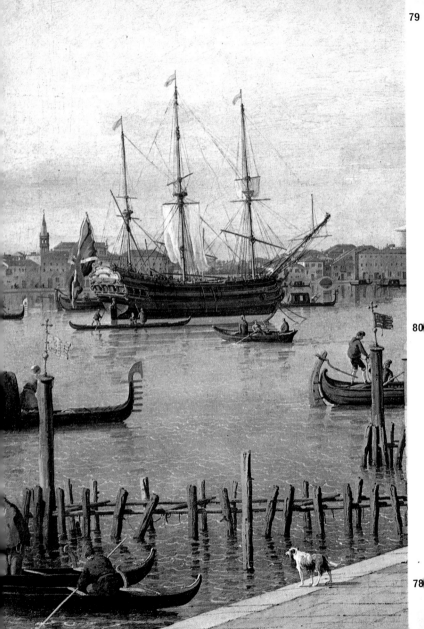

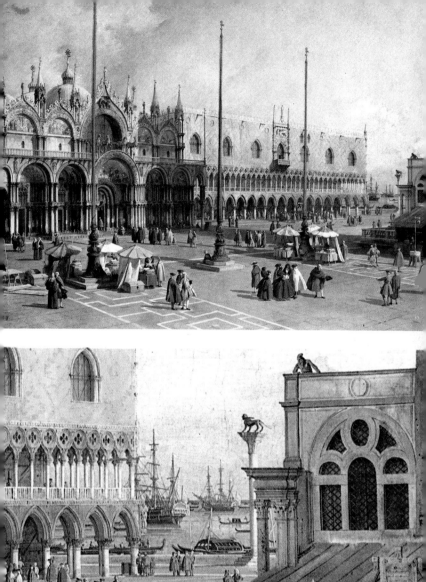

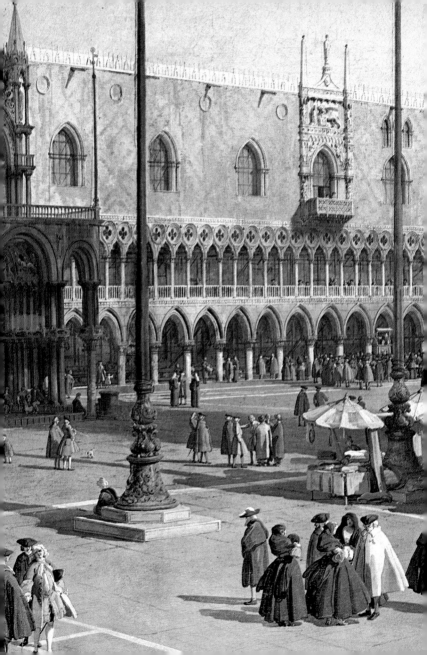

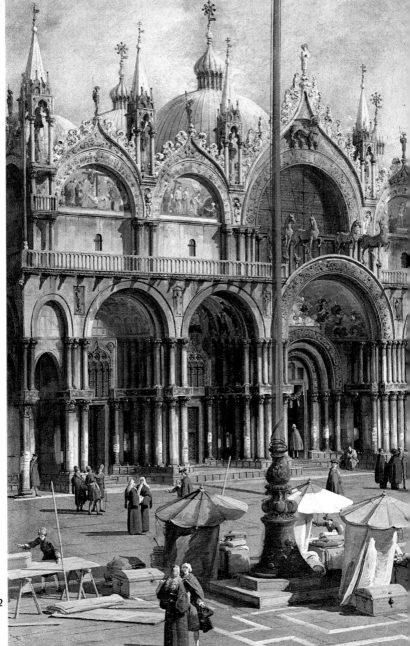

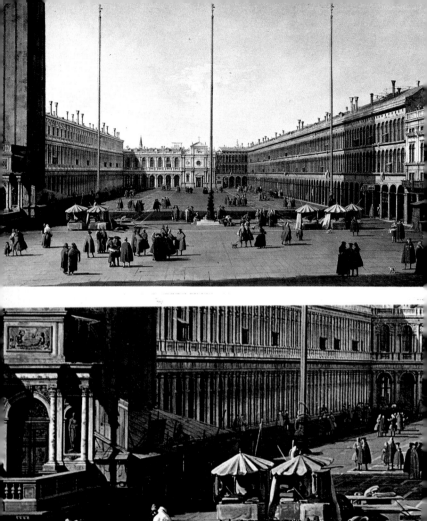

83

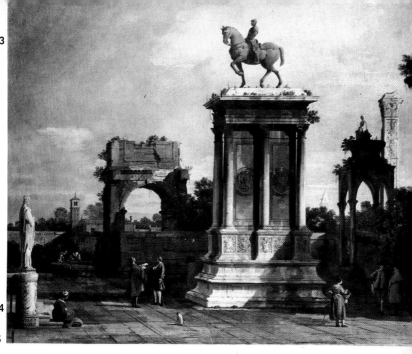

84

85

86

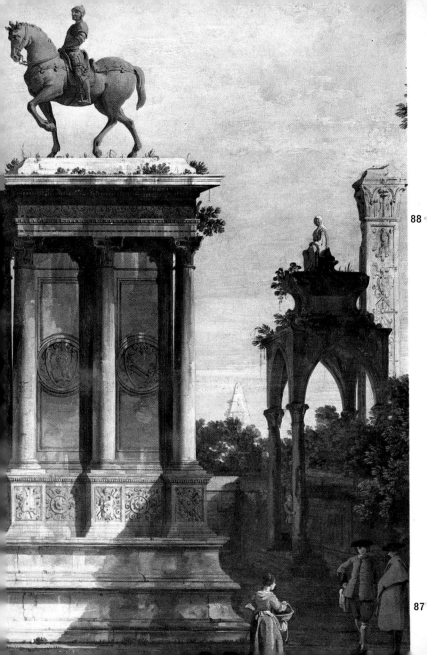

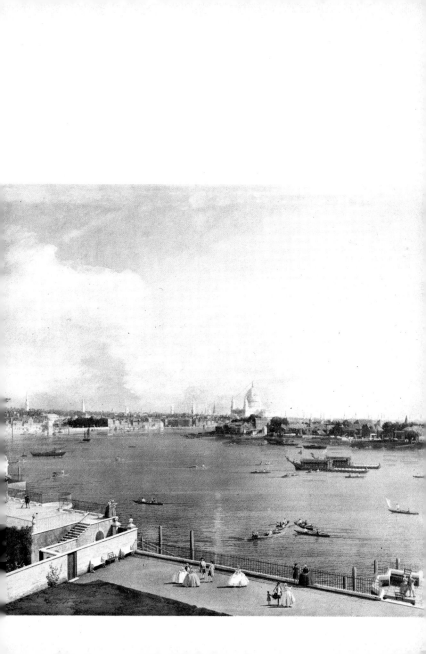

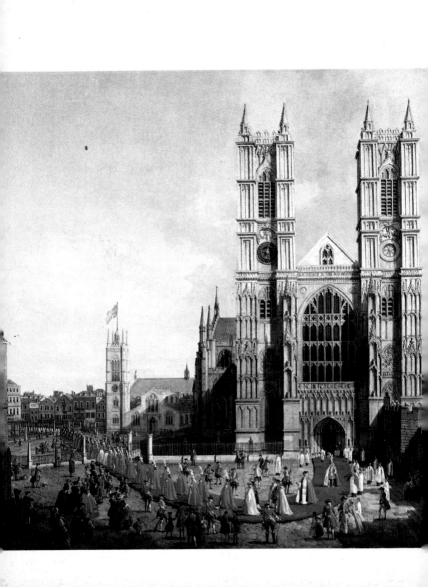

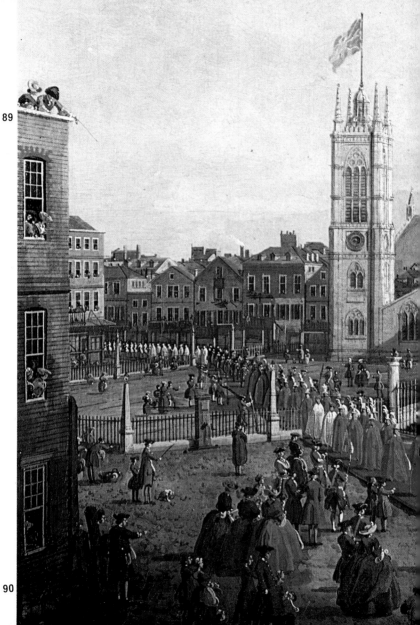

89

90

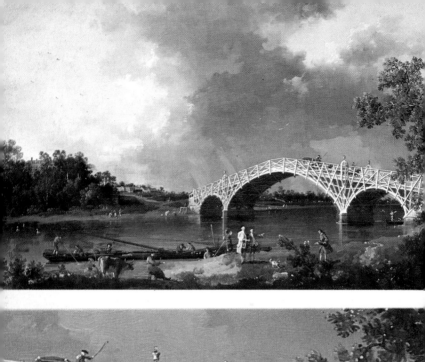

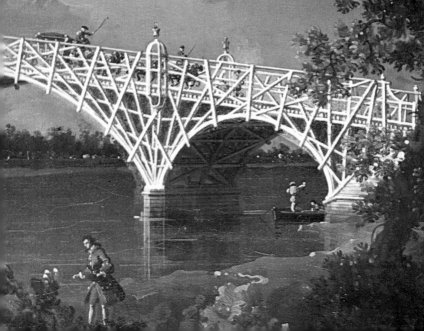

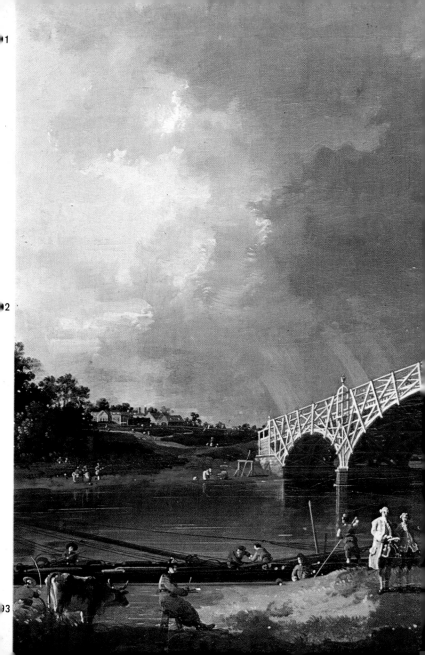

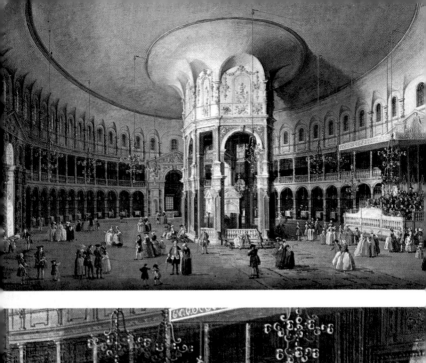
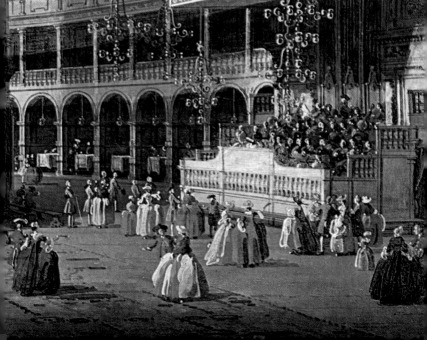

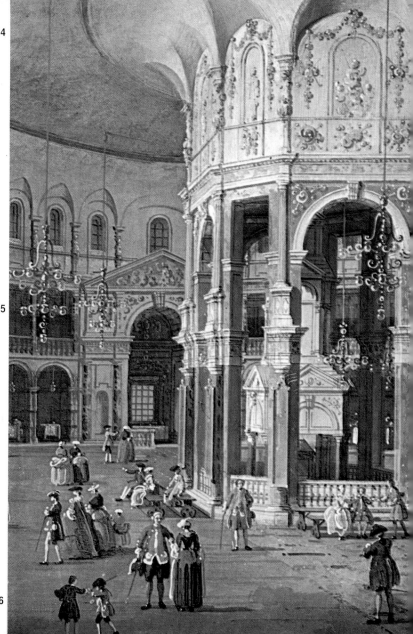

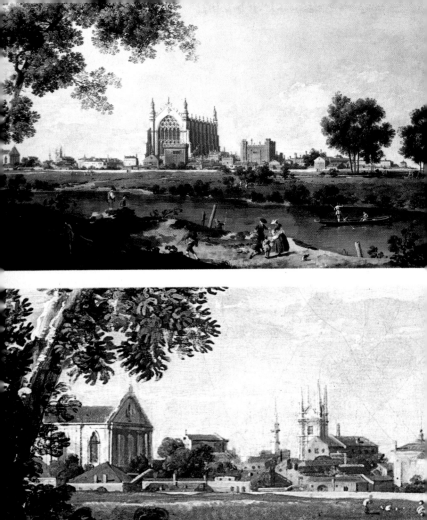

97

98

99

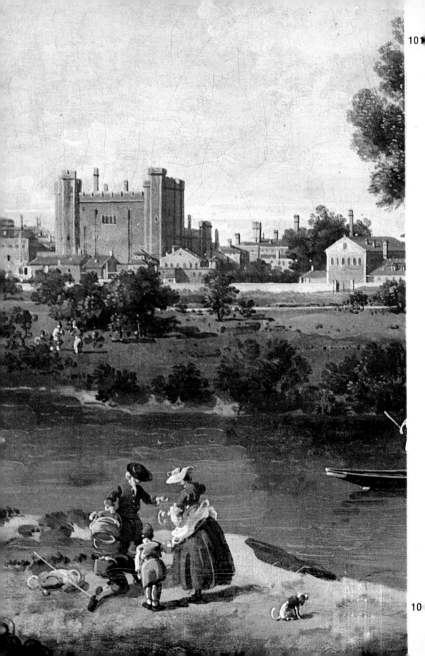

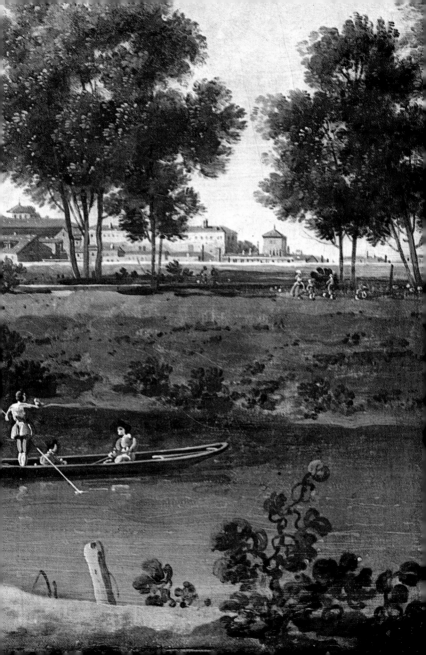

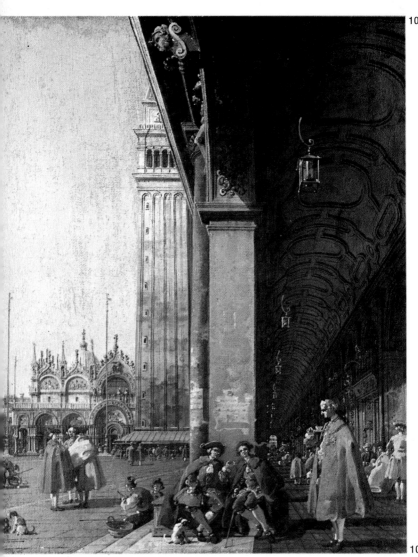

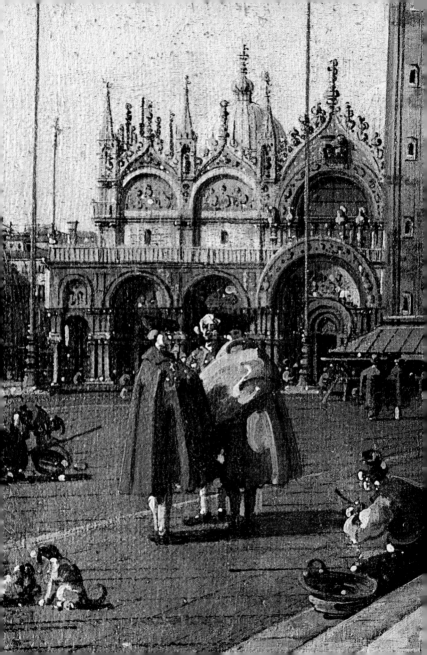

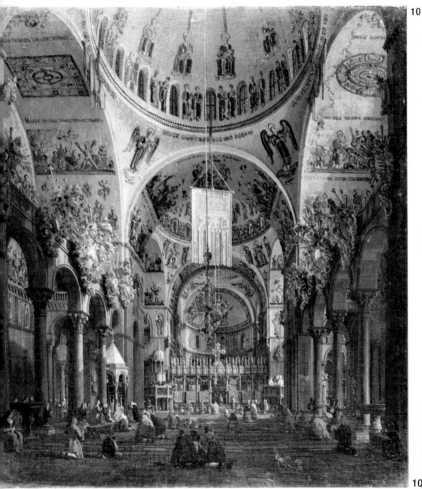

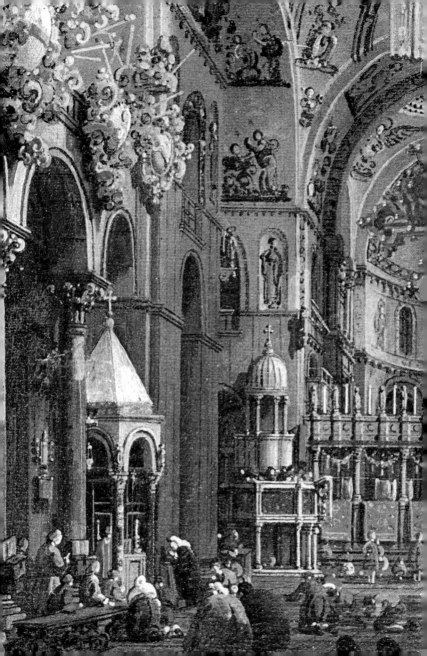

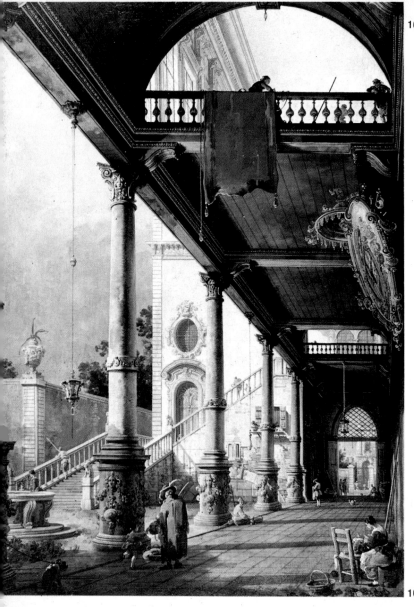

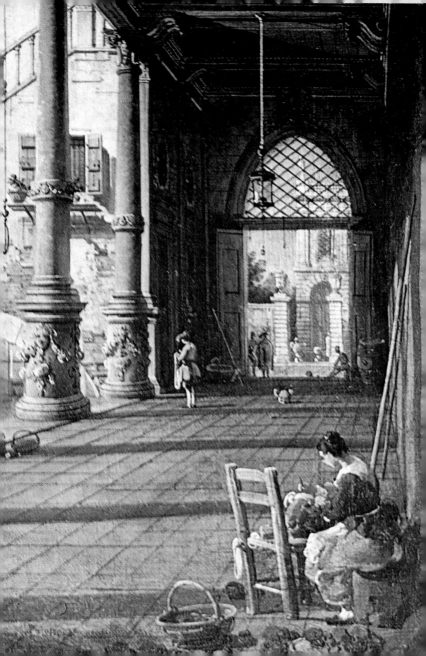